Paolo Rosselli **Architecture** *in Photography*

Architecture

Paolo Rosselli

in Photography

SKIRA

Art Director
Marcello Francone

Editing
Giorgio Bigatti

Layout
Fayçal Zaouali

Cover
Herzog & De Meuron, Tate Modern, 2000

First published in Italy in 2001 by
Skira Editore S.p.A.
Palazzo Casati Stampa
via Torino 61
20123 Milano
Italy

Printed and bound in Italy. First edition

ISBN 88-8491-014-5

Distributed in North America and Latin America
by Rizzoli International Publications, Inc. through
St. Martin's Press, 175 Fifth Avenue, New York,
NY 10010.
Distributed elsewhere in the world by Thames
and Hudson Ltd., 181a High Holborn,
London WC1V 7QX, United Kingdom.

Acknowledgements

Although the sequence of the photographs, as well
as the arrangement of the various works, reflect the
choices of the writer, I must also recognise that the
opinions of a few friends were essential to this
work. Listening to advice and observing the
reactions of those glancing through these pages
convinced me to bring the volume closer to its
theme, contemporary architecture, and thus to
exclude images from other sources.
The suggestions of Pierluigi Nicolin caused me
to reflect on the link between topic and image,
convincing me to avoid superfluous digressions.
Alessandro Rocca indicated some solutions that
make the structure of the volume clearer to me and
encouraged me to visually underscore certain
passages. Elisabetta Berla studied the sequence
and indicated some photographs whose presence
was not effective. The counsel of Jeff Jennings also
played an important role in the selection of certain
images.
I must express special gratitude to Santiago and
Tina Calatrava for their generous friendship. I would
also like to mention the architects I have known and
collaborated with during this period: Juan Navarro
Baldeweg, Mario Botta, Manuel de Solá Morales,
and Gino Valle.
The strong support and friendship of José Charters
Monteiro of Lisbon were essential in the
preparation of initiatives linked to this publication.
The same applies to my friend Enrique Arellano
Farias of Mexico City.
Other persons acted as observers during the
various stages of the work: I am indebted to
Malcolm Frost, Michele Burckhardt and Susanna
Magistretti. A word of gratitude to the editors of
Lotus International for their collaboration in so
many projects and to Jennifer Stoots of SKJ Studio
Portland, Oregon.

Paolo Rosselli, May 2001

Contents

Dennis Sharp

Paolo Rosselli and the Photographic Eye

"The mission of the photograph is to clarify the object"
Lewis Mumford, *Technics and Civilization*, 1934

The modern photographer is the architect's greatest publicist. Almost all the initial judgements made about the work of an architect are made on the basis of images. They are made much less frequently on the basis of first hand experience of a building. It is therefore the photographer's own vicarious experience of the work of architecture that produces the significant images which convey its essence. In developing a building concept the architect looks; the architectural photographer sees – and selects.

Open any book on architecture and one is immediately impressed by the variety of colour and black and white photographs that convey the perceived reality and often the potency of a new building. It is true that the photographic image (and now the digital image) is the main component of a presentation and a date record of the structure depicted. That the photograph has replaced the engraving, the line drawing and the "artist's impression" or perspective presentation is also true. However, there has been over the past few years a hesitation on the architect's part to accept that the photograph is a replacement for these previous means of communication.

During the development of the Modern Movement in architecture, architects relied on black and white photographs to convey the impressions of their buildings. These pictures helped form the "image" of early Modernism. They were dependent upon the photographer's interpretation of the building at the expense of its chromatic values and surface finishes. The use of colour film – although more generally introduced for architecture from the 1920s – hardly made an impact. Most papers and journals of the heroic period

of Modernism conveyed their images of a new architecture through high contrast black and white images, a way of conveying the essence of architecture that is still immensely popular today even with all the interest there is in colour.

The photographers of modern architecture portrayed artefacts with simple and clearly delineated surfaces, with plain walls inside and out uncluttered by the traditions of decoration of the architecture of the past.

Today the photographer who specialises in taking pictures of buildings but does not necessarily do so exclusively, assumes a much more prominent role – one analogous in some ways with a film director or a pictorial chronicler. Few lack the necessary technical knowledge and photographic skills but many lack a real understanding of architecture and the design process that has brought about the design. A serious gap therefore exists between those photographers who simply service the architectural profession and those who use their skills, knowledge and intuition in a creative way. Photography is a way of looking as well as a way of recording. In the way that this act of seeing is used and the thoughtfulness of the artist behind the camera can produce the most remarkable results. An architectural subject – even a detail – can be etched into the mind of an observer by a unique and memorable image that not only elaborates the architecture but also often brings out latent or even previously hidden qualities. But the image – until quite recently – represents a unique aesthetic moment. The photographer cannot re-arrange his material on his own. As Lewis Mumford wrote in 1934 the photographer "must take the world as he finds it".

Mumford's mission statement quoted earlier was made at a time when photography was struggling to identify itself with art as a

legitimate art form. It achieved it, of course, and the whole history of the recent past in photography substantiates that claim.

Paolo Rosselli's work exhibits such qualities. His work is at the leading edge of his profession. It is distinctive and personal. The photographs he takes are not there to just satisfy the whim of the architect. He is creating his own art form. As a professional photographer Rosselli looks very carefully at what he sees. He then selects and revalues, elucidates and shoots. It may be easy to apply the phrase "the photographer's eye" in generalising about such a process. The phrase itself is a cliché in a sense but still useful in that it underscores the thoughtful aspects of the process of "seeing". In Rosselli's work it produced those special images that do not simply replicate the scene – in a frozen and therefore partial sense – but enhance the whole subject.

Undoubtedly his ability to compose and "visualise" an object can be attributed to his early training as an architect. This I believe directs, instinctively, his way of seeing spaces, distances and surroundings. One of the essential elements in this "seeing" is his understanding of perspective. Perspective cues, as Professor Richard Gregory pointed out many years ago in his famous book *Eye and Brain*, are made use of only after considerable experience – when an artist employs geometrical perspective he does not draw what he sees, he represents the retinal image. He comments further: "A photograph represents the retinal image, not how the scene appears...".

Photography for an architectural photographer of Rosselli's calibre is not just a studio based activity – even though much time may be spent there producing the final image from film – it is expansive and outgoing. The prevailing climatic condition in which the photographer rules is outside and usually in the light of day. In his well-known book

on architectural photography Eric de Maré, the doyen of British architectural photographers, commented that taking photographs of architecture was like "building with light". The architect of a building uses light and shadow creating similar contrasts in the early stages of a design to those pursued by the photographer observing the final result in a play of light.

Focal Points and Symmetry

Rosselli's interest in perspective can be seen clearly from the earliest of his architectural prints. This interest lies not in an emphasis on perspectival effects as, say, with that of the Renaissance painters but rather the way a perspective image can be transformed and opened up, to reveal more behind the subject. He does this by taking into account a wide horizontal frame. Unlike other architectural photographers who are keen to get up close to their objects – like a cloakroom attendant brushing off a speck of dandruff from a client's jacket – Rosselli uses distance to impact the horizon on the building or group of buildings. His well known photograph of Santiago Calatrava's airport and TGV station at Lyons Satolas shows the photographer himself in the foreground, personalising the image and giving an indication of the building set in broad country like a bird on the ground. He used a wide-angle for this memorable shot.

Distance in the contrived world of the photograph can itself be seen as a device. Lee Friedlander's experiments with mirrors to give a collaged reality to an image are taken up frequently by Rosselli to suggest the condition of a place. The cultivation of more than a single viewpoint thus emphasises an ambiguity in the photograph. On the one hand it suggests a seemingly endless opportunity, on the other it enlarges the conscious presence of the artefact. Déja vû becomes a

present reality. Mirrors can provide a variety of images dependent on their positioning and reflections. Thus a complex, in depth – even narrative – like image results. In Rosselli's case it has been a stimulus to further experimentation and he has recently been experimenting with the manipulation of computerised digital images. With these he is seeking to transform and enhance the perceived image by the use of colour rather than with formal changes to the subject. By this means he enlarges the scope of the picture to give it an extra qualitative dimension.

Methodologies

Rosselli began his work in 1984 when he initiated a study in Engadin, Switzerland, by photographing its buildings, the wider landscape and scenes of daily life. This work formed the basis of an exhibition "News from Engadin" held in the Architektur Museum in Basel. It underscored his search for a positive coherence in the types of views and distances chosen for the subjects he photographed.

Writing about his techniques and methods of working Rosselli has commented: "Looking and thinking at the way I work ... I try to produce a sequence and not just a number of 'single' shots. When I look in the viewfinder and I take that picture, I am already prepared for the next one. I normally take a lot of pictures until I feel that I have reached a satisfactory analysis of the project and of its spaces. Normally I will spend three full days in a place working throughout the day and sometimes during the night. It happens that I will repeat some shots when I think I can improve the quality of the picture or the light is more adequate for that shot". Rosselli continues: "I should say I always try to produce different versions of a photo, especially when I think that particular view has something important to show – I

have different cameras and normally I know in advance which one is the more suitable for that particular work. I pay great attention to the scene of the project: as a place that may contain something unexpected (light, moving objects, people). It is these elements that can change the quality of a picture; sometimes I wait for minutes, at other times for hours. I should say that in some way I need this context as a background of my picture. Consequently I am very careful in rendering this space whatever it is".

In the vertical shot of a building by Luigi Moretti, for example, Rosselli shows a triangular arc of light on the right side of the picture – a shape that is analogous to the building's shape. He often takes a picture made into a "traditional" composition but then includes something "extraneous" and at the same time "revealing" more about the project. He seeks to look at architecture from different distances, to verify the visibility of the building. Look, for example, at the photograph of Gino Valle's project taken from the Neuilly Bridge in Paris. Here the building is very small, but still visible. Around it you can see many things: the building of La Défense, a pedestrian bridge on the right side, the river below, poles etc... Rosselli claims he is less interested in the detail of a building and more in its impact as a comprehensive subject. He does not eschew the close-up view. In order to achieve a complex image with a close-up he uses a wide-angle rather than a telephoto lens thus maintaining a complexity of image without extracting or isolating a specific building detail or element.

He uses two different wide-angles and a normal lens but very rarely a telephoto. He also uses a shift lens for architectural photographs but claims it is not essential. He uses the Hasselblad in his work because it is a light camera and the quality of the lenses is unsurpassable. In

1984 he used to work with a 35mm Nikon with two shift lenses (see the pictures of the Conservatoire de Musique in Paris). He now prefers to work with medium formats. However he is now giving thought to other techniques, notably digital ones.

New Digital Techniques

Speaking about digital techniques, Rosselli says: "As photography is very complex as a technique, the efforts of a photographer are intended to dominate it. The digital technique is new and it will change all the paradigms connected with photography. It is only used now to about five per cent of its potential but is already producing enormous changes in photography". The photographer indeed, has to decide which way to go and define the areas in which digital techniques can be used to intervene or to interfere. Interference is the most interesting aspect of digital imaging both to choose a gradual and limited intervention on a photograph, for example, or to improve or change the colours without sacrificing the structure of the image. "Sometimes" he says, "you can look at an image on a monitor and enlarge it up to 400% and you discover colours that were not previously visible. The blue in the dark side of a room for instance. Colour film today is accurate but it can be improved in its precise rendering of a space".

Rosselli is convinced that it is possible to have a visual memory of a place, which is not always conveyed by the photograph. It can then be improved by digital means, through the computer and the idea of virtual reality. The image appears more ductile and less mechanical than chemical photography and indeed, "much closer to our own desires and expectations".

Rosselli has graduated recently to the use of PhotoShop and the digital manipulation of images. The "digital" is at the moment, he claims, "a kind of new artisanal work, although manipulation with the computer is quite laborious". He can spend one and a half hours on a single picture to select, he says, the colours of the interiors of the Petit Maison. After this operation he needs to verify the print, its contrasts, colours and then to print it a second time to obtain a satisfying image. He recalls: "A different and easier process was used when I turned black and white photographs into colour ones. I decided that I needed brown, yellow and blue in three different areas of the print: the only thing to do was to choose the gradation of the colour".

PhotoShop, he feels, does not distort the image; it is a new and experimental instrument in the hands of the photographer. "As always there is an idea before you start this long work: improving/reducing the colours is an aesthetic choice and not the way to solve problems of a poor image".

Modern architecture is totally different from the architecture of the past. The way modern architecture reveals itself is substantially and strongly visual. Rosselli recalls a recent visit to Le Corbusier's monastery at La Tourette (his first visit there was in 1974) when he looked through the strip-shaped windows framing the landscape outside, and noted "that the colours inside were yellow, blue, green, red but never grey".

Sources of Inspiration

From the time he started work as a photographer, Paolo Rosselli read widely about photography and printing techniques, building up a collection of useful and rare photo books.

After graduating in architecture he started on a self learning curve

of photography building up his newly acquired knowledge by looking at the work of other photographers such as Eugene Atget and the American avant-garde photographer Lee Friedlander. The latter's intelligent construction of a sequence of images and his establishment of a relationship between two images (left/right) had a lasting influence on Rosselli's urge to experiment with place, distance and relational imagery. And there were other influences too on his work and theory including Walker Evans and Ed Ruscha.

His concern with photographic theory follows that of some of the artists and architects of his own generation who attempted to grasp it. Italian theorists, in nearly all the arts, were looking for a framework of critical theory in the 1970s and 1980s. They looked – as did many other Europeans – to the French semiologist Roland Barthes, the literary theorist of Zero Degree. Barthes was intent on removing writing from the subservience of literary style which one has to leave behind, and rely on what he called a basic language. His own semiological approach to literature was appreciated by some critics in support of a discussion of signs, meaning and messages that spilled over into the analysis of the history of architectural theory. Much of this discussion was concerned with space and images. Critics such as Bruno Zevi wanted to emphasise architecture's essential properties – that of internal or enclosed spaces. It has a parallel in photography. It is through the process of experiencing a building that the internal spatial aspects become apparent, Zevi argued. By assuming that architecture has a concrete experiential reality – and an internal/external dichotomy – then it cannot be represented by space alone. In a sense it revolves around the notion of its significance as an individual and subjective experience. This empathic view has its relevance – and its field of experimentation – in the even more subjective and selective realm of photography where reality is grasped by a non-real two-dimensional image. Although perhaps an unusual source in the sense that Barthes theorises about many subjects but little on photography (except for his essay "La Chambre Claire"), Rosselli found in his work a helpful philosophy for the understanding of the relationship between media, art, literature and criticism.

The photographs published in this book were commissioned by architecture journals, reviews and architects. There are some exceptions to these avenues and that is the work taken by the photographer for his own interest.

However this wide variety of sources is linked all the way through the book by a sense of continuity and consistency given by the work. It helps to make the collection legible and is a remarkable testimony to the work of one of the most original architectural photographers at work today.

Luigi Moretti

Aldo Rossi

Gino Valle

Christian de Portzamparc

Manuel de Solà Morales

Rafael Moneo

Manuel De Solà Morales

Santiago Calatrava

Renzo Piano

Herzog & De Meuron

Frank O Gehry

Mario Botta

Cruz y Ortiz

Juan Navarro Baldeweg

Ian Hamilton Finlay

Arata Isozaki

O.M.A

Le Corbusier

Frank Lloyd Wright

Architecture *in Photography*

Milan, 1992
Luigi Moretti, Office Building, 1951-56

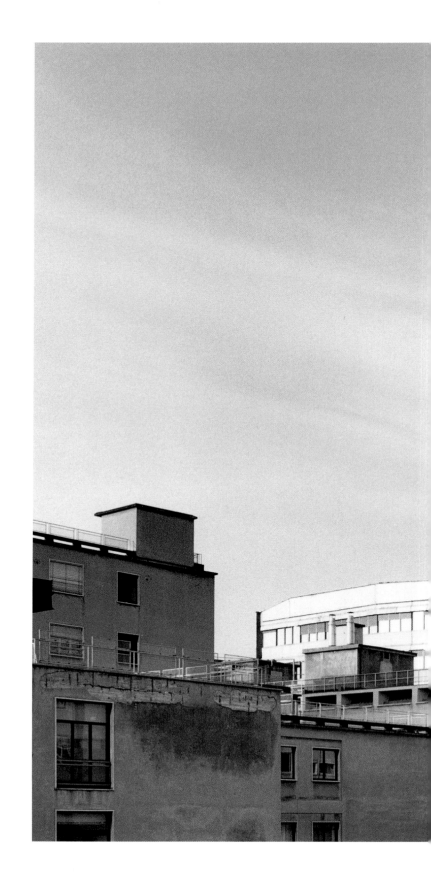

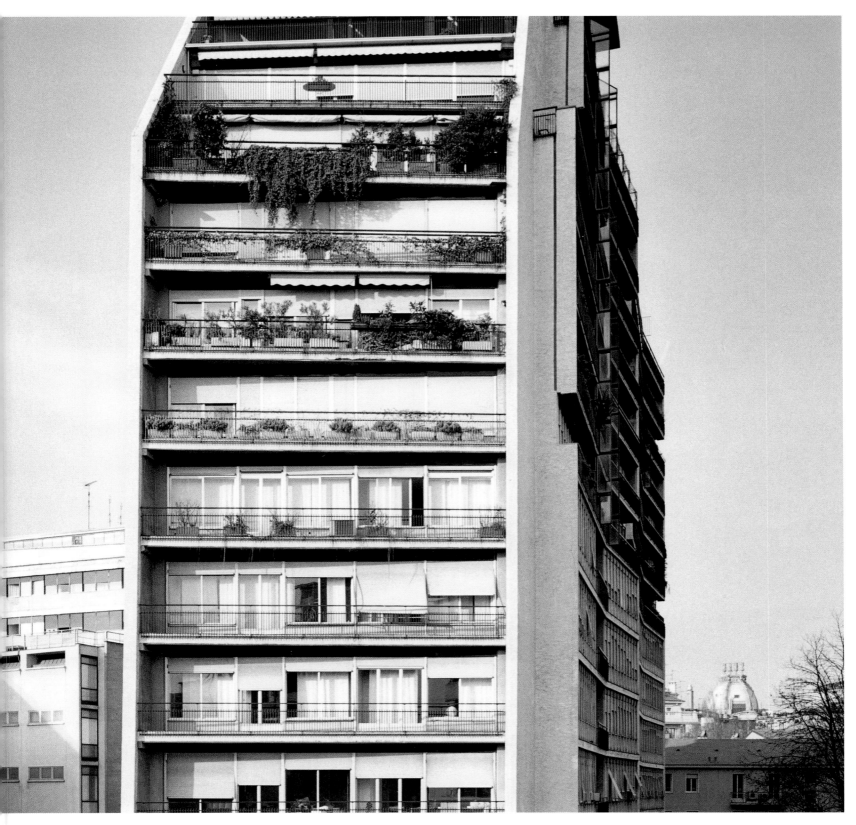

Milan, 1992
Luigi Moretti, Office Building, 1951-56

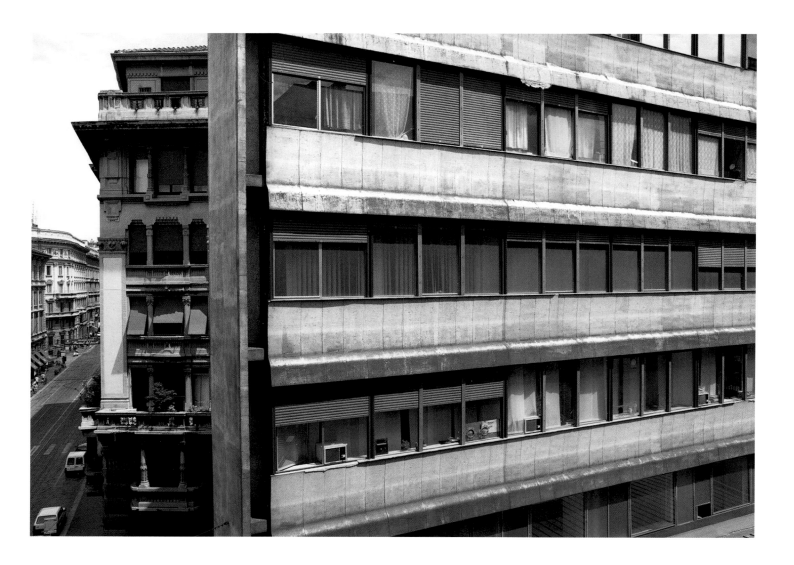

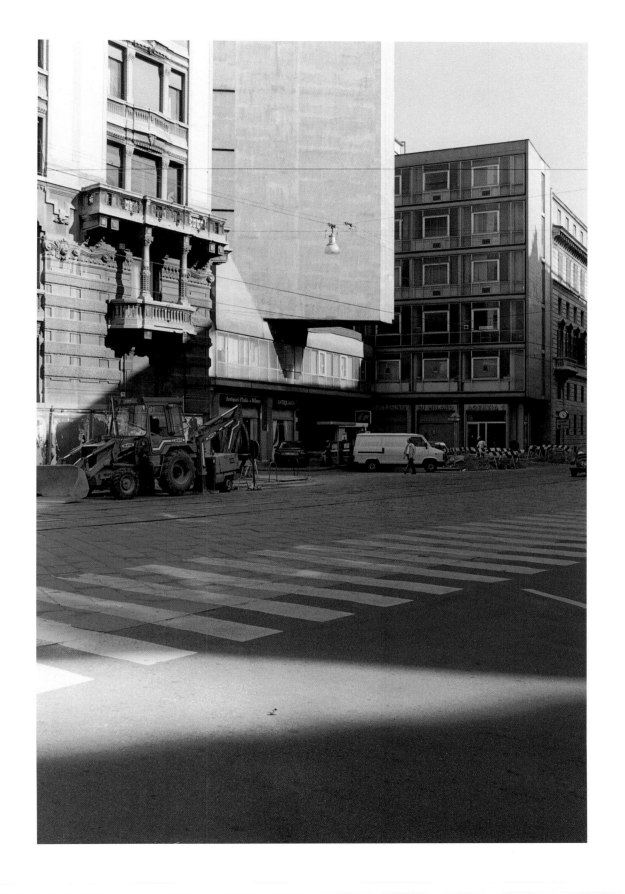

Genoa, 1991
Aldo Rossi, Carlo Felice Theatre, 1991

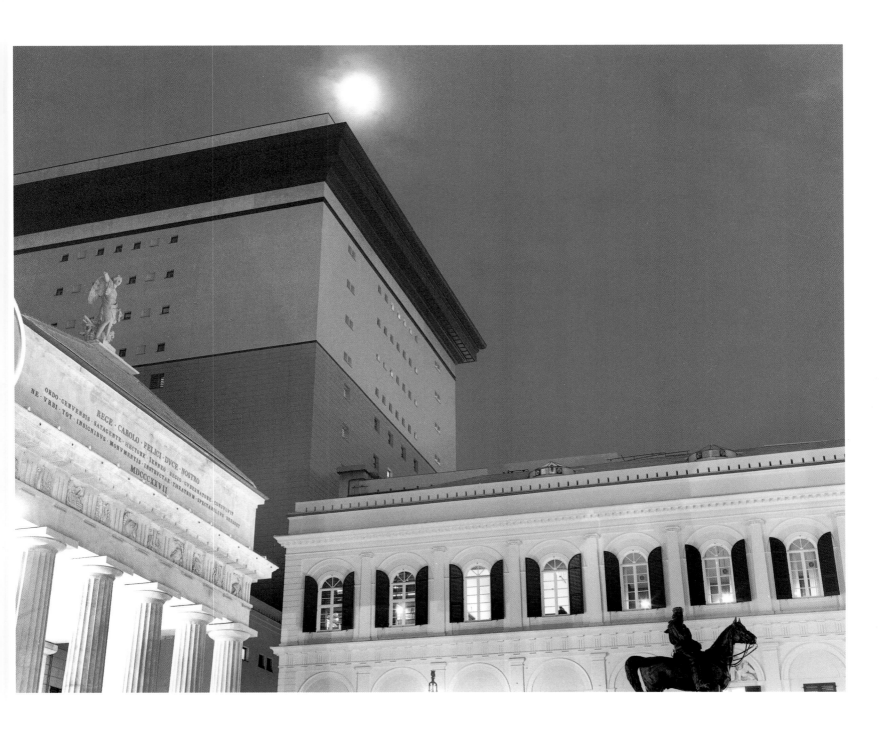

Genoa, 1991
Aldo Rossi, Carlo Felice Theatre, 1991

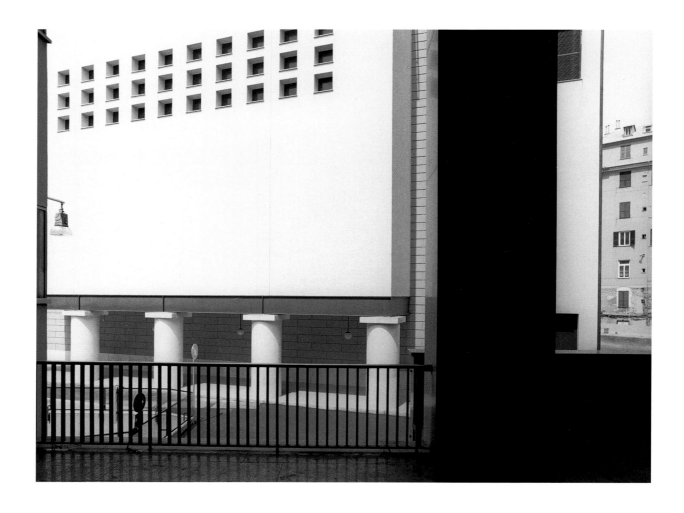

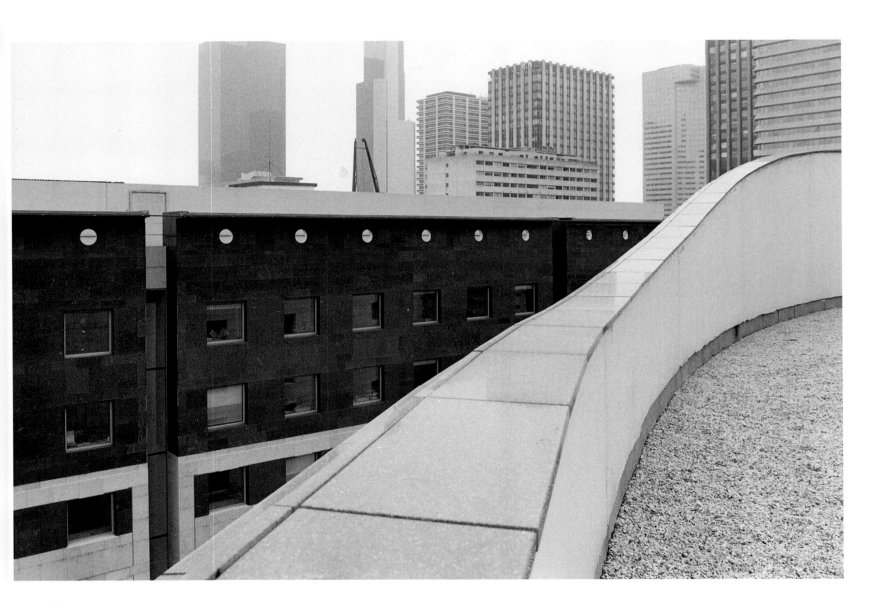

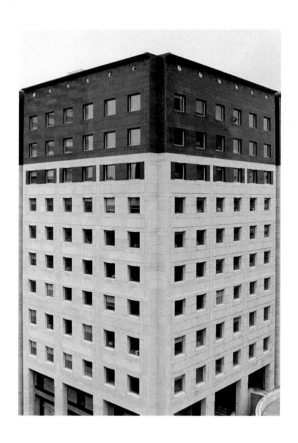

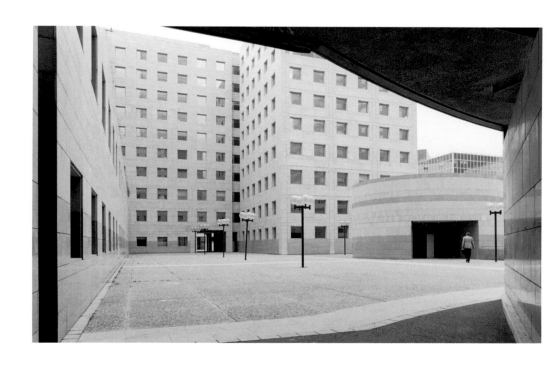

Paris, 1989
Gino Valle, Offices and Hotel, Défense, 1989

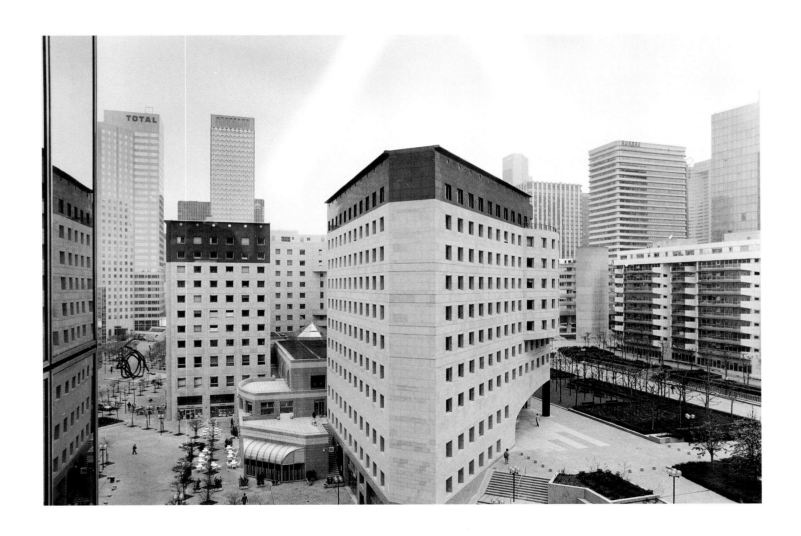

Paris, 1989
Gino Valle, Offices and Hotel, Défense, 1989

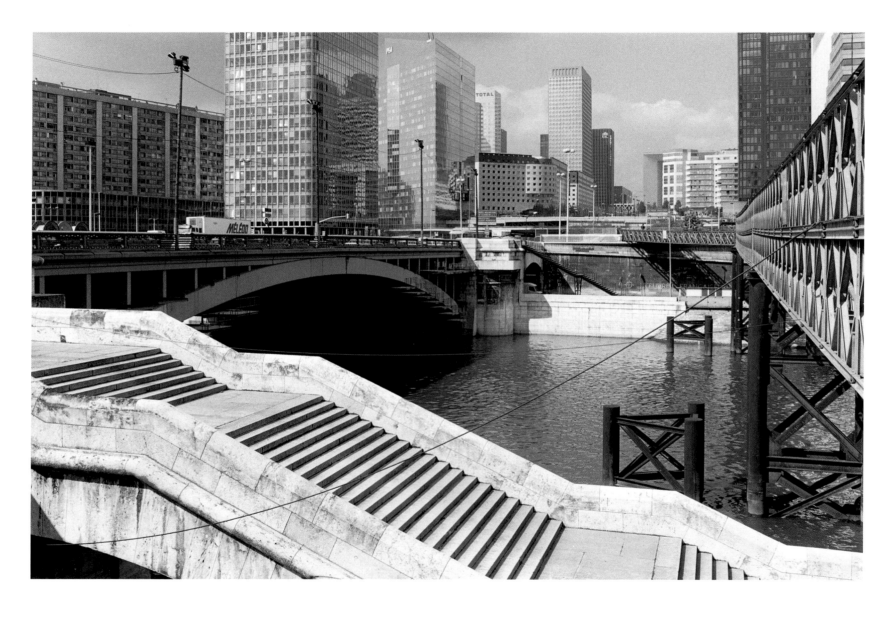

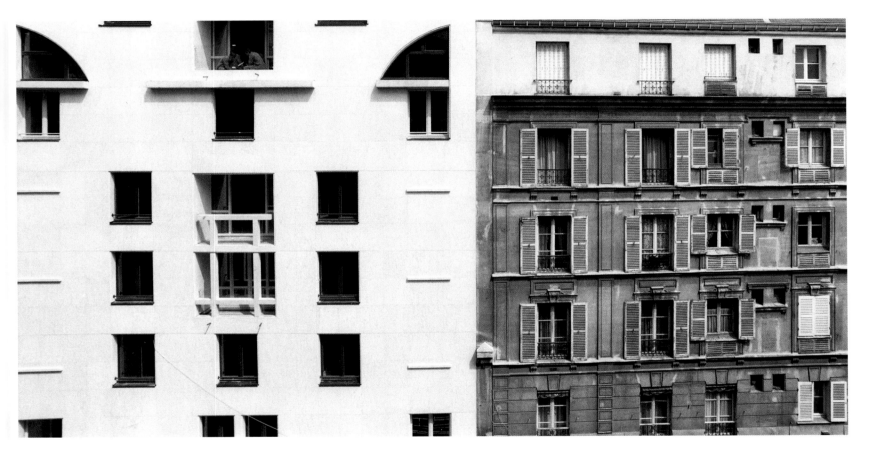

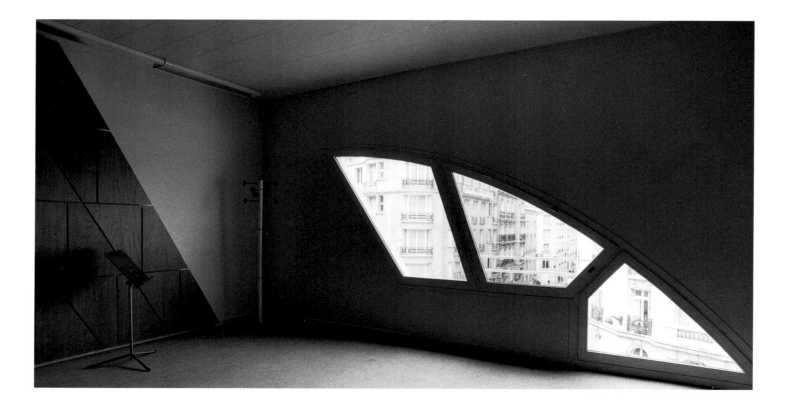

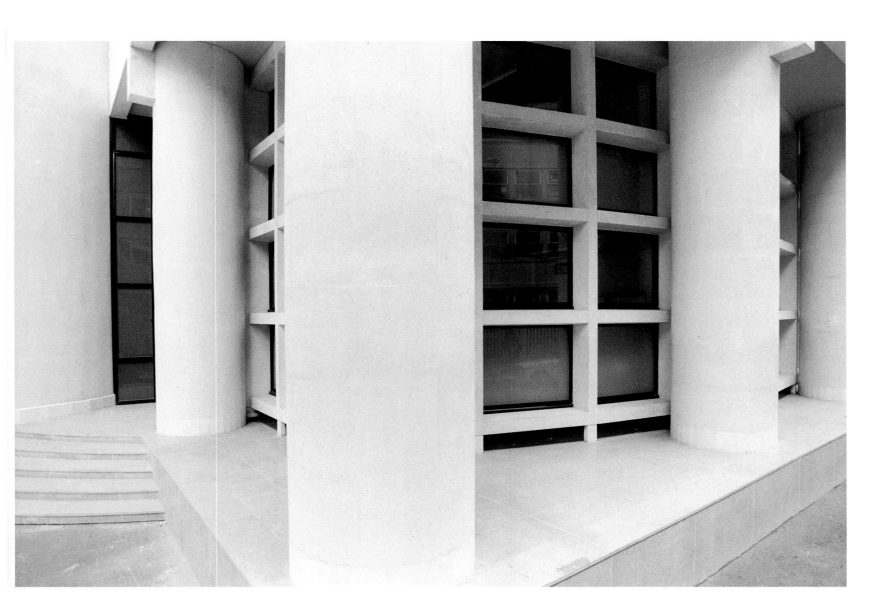

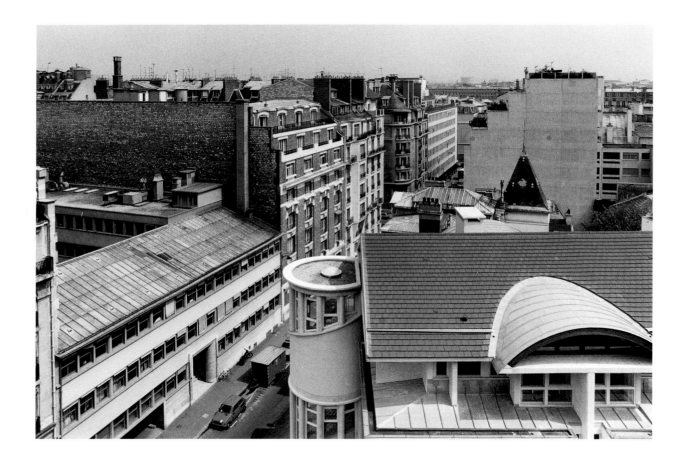

Barcelona, 1987
Manuel De Solà Morales, Moll de la Fusta, 1986

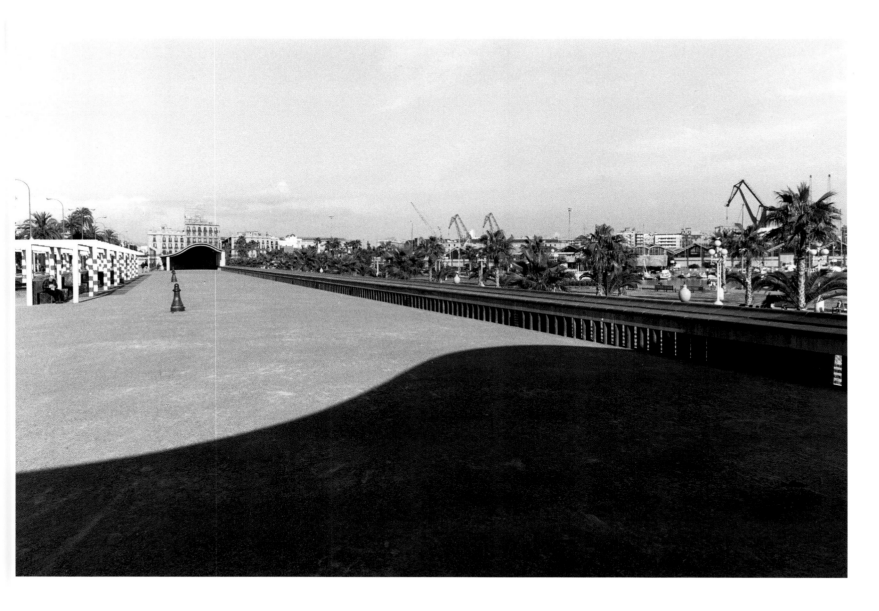

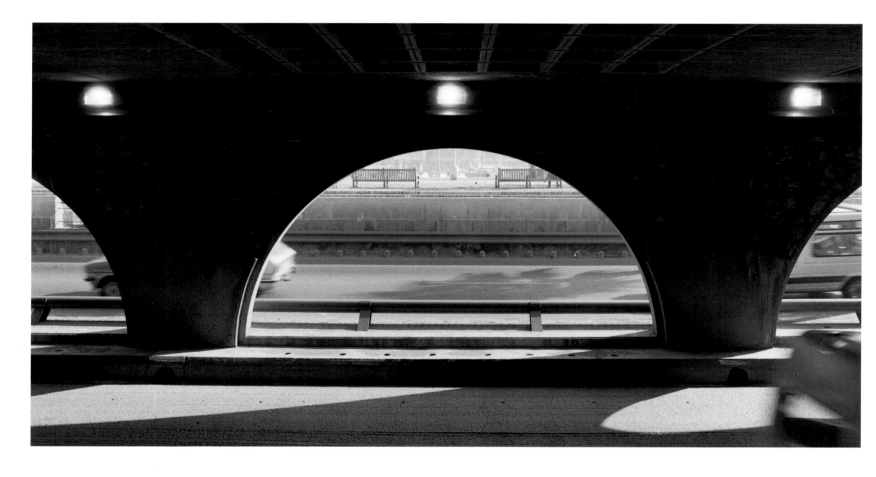

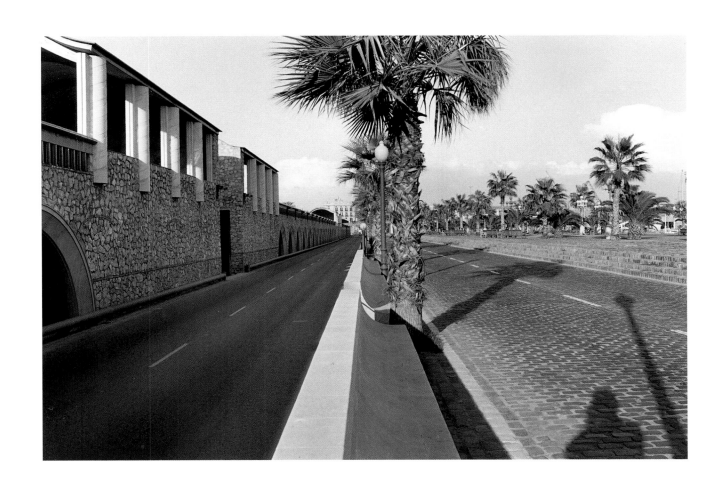

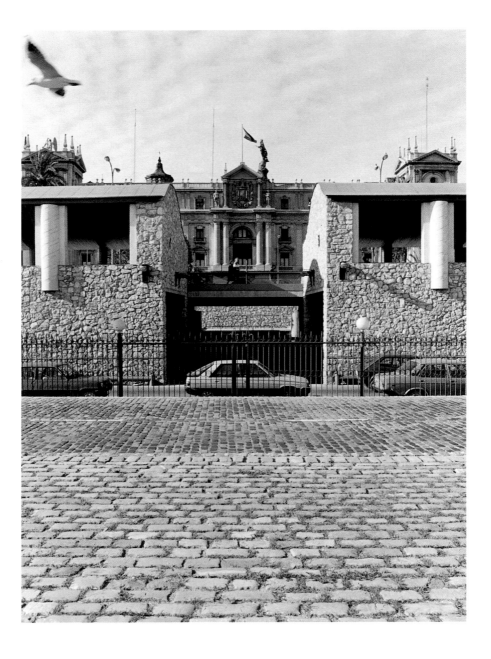

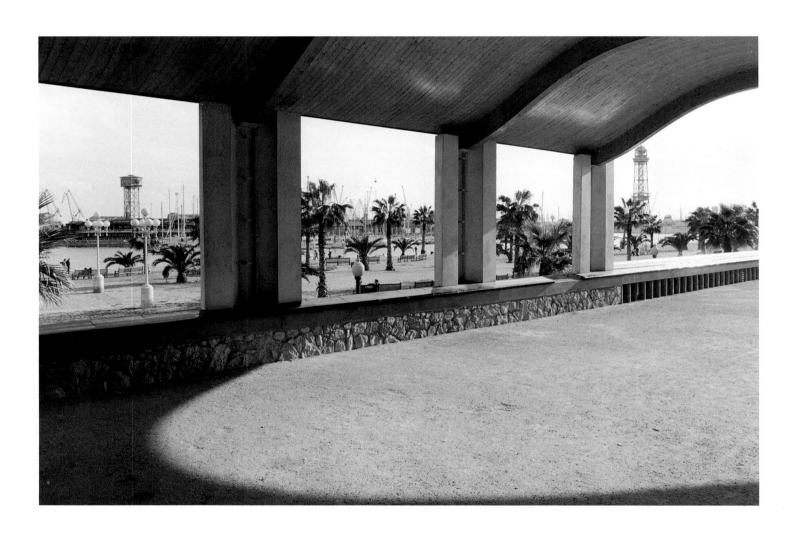

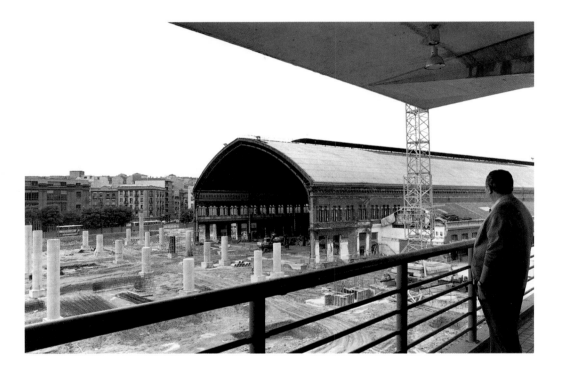

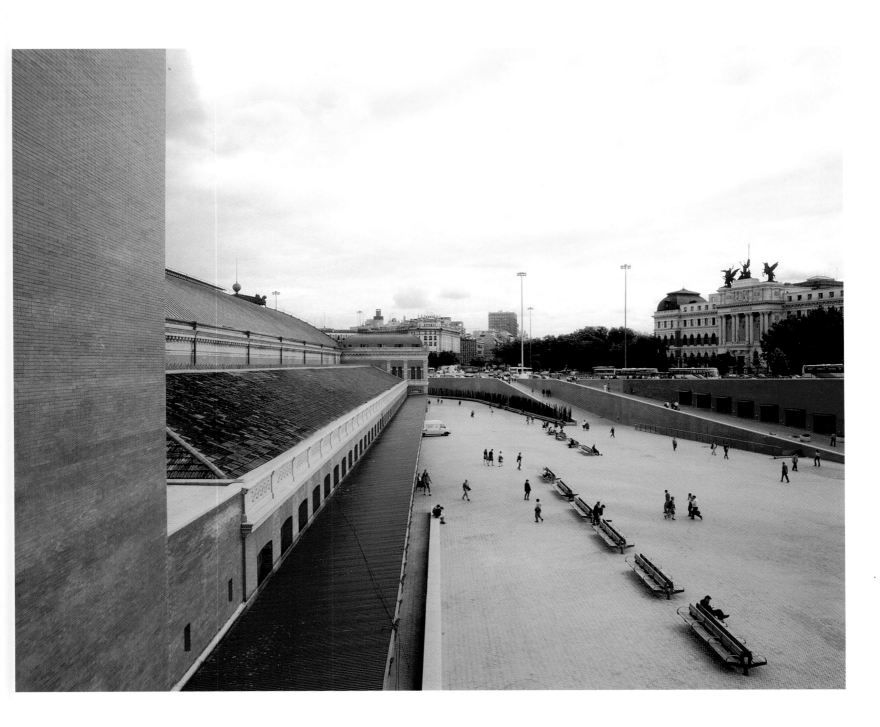

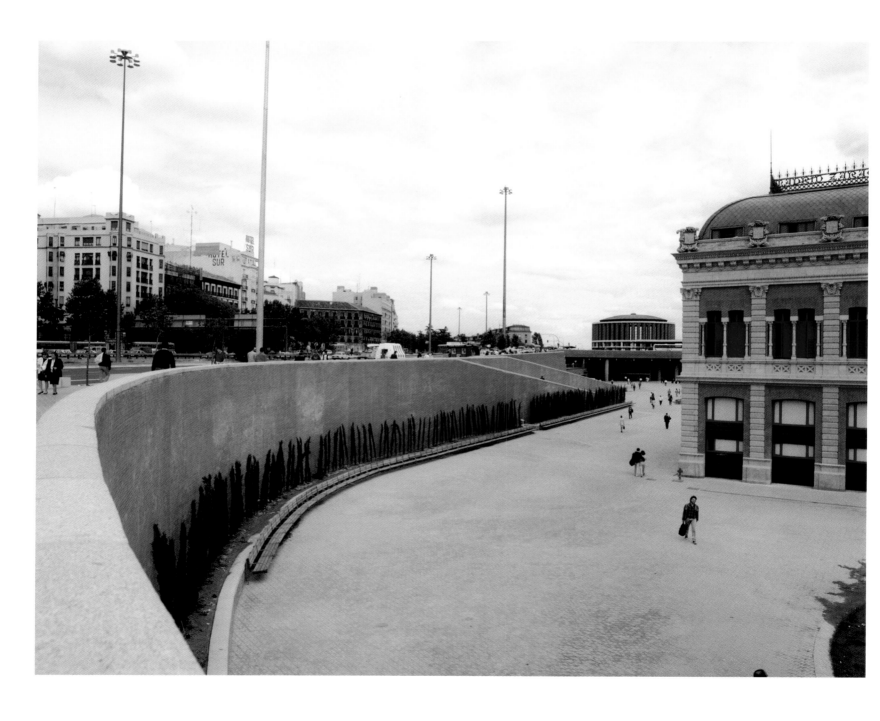

Madrid, 1992
Rafael Moneo, Atocha Station, 1988-92

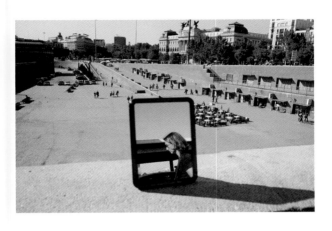

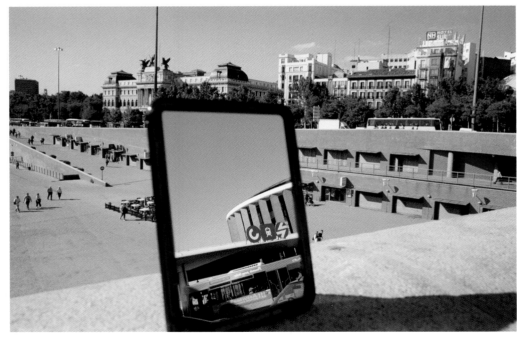

Madrid, 1992
Rafael Moneo, Atocha Station, 1988-92

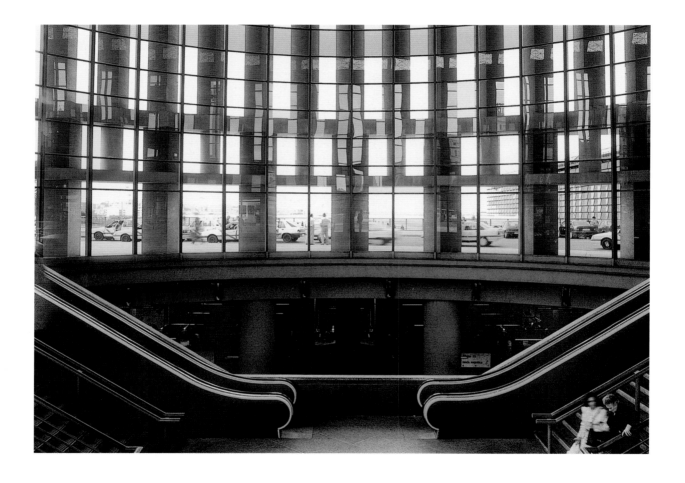

Barcelona,1994
Manuel De Solà Morales-Rafael Moneo,
Diagonal Block, 1989-94

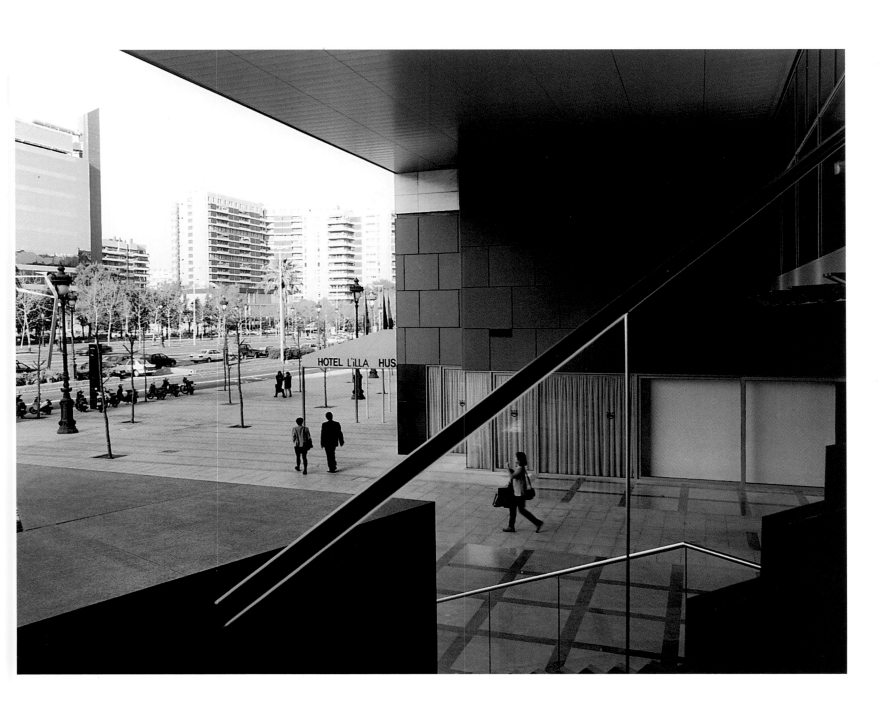

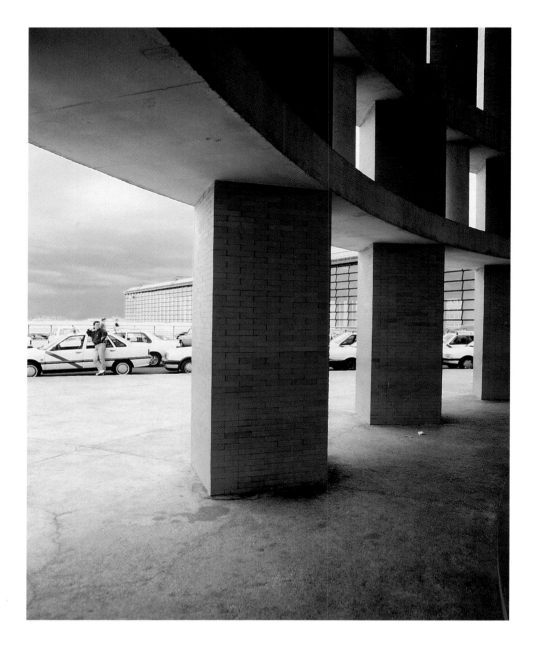

Barcelona,1994
Manuel De Solà Morales-Rafael Moneo,
Diagonal Block, 1989-94

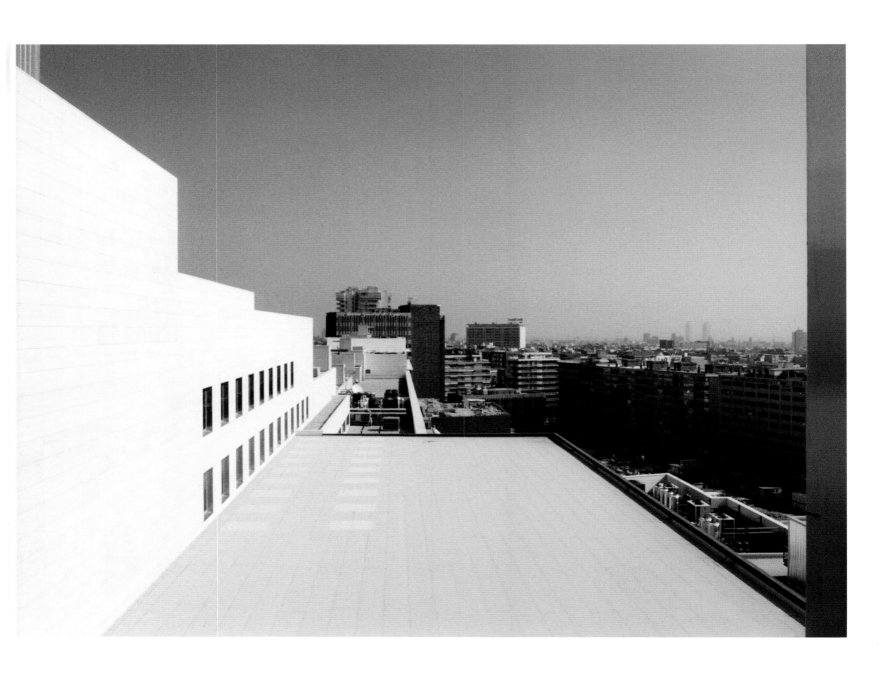

Barcelona,1994
Manuel De Solà Morales-Rafael Moneo,
Diagonal Block, 1989-94

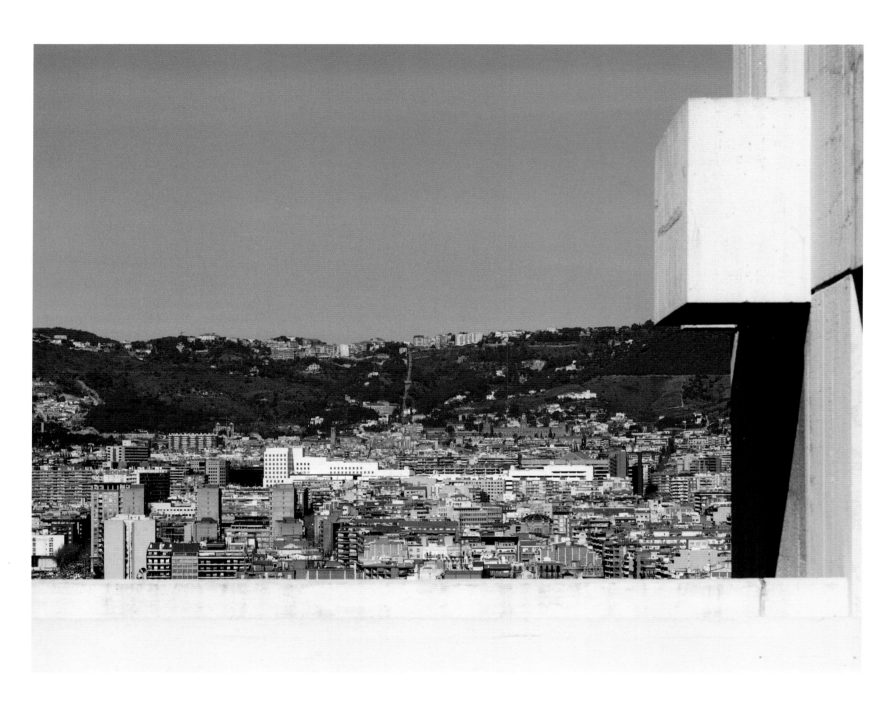

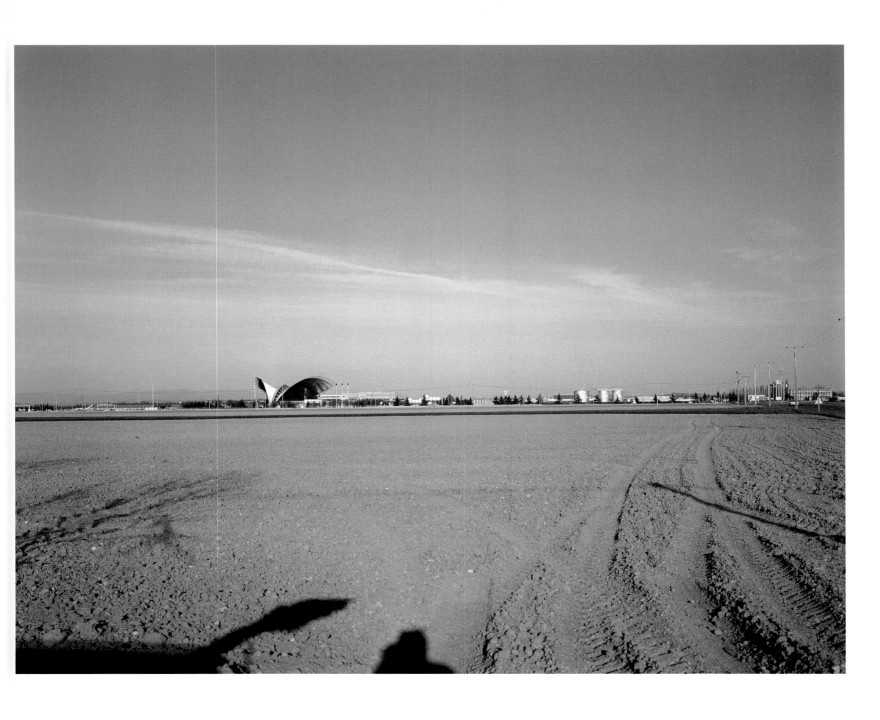

Lyon Satolas, 1995
Santiago Calatrava, TGV Station, 1989-94

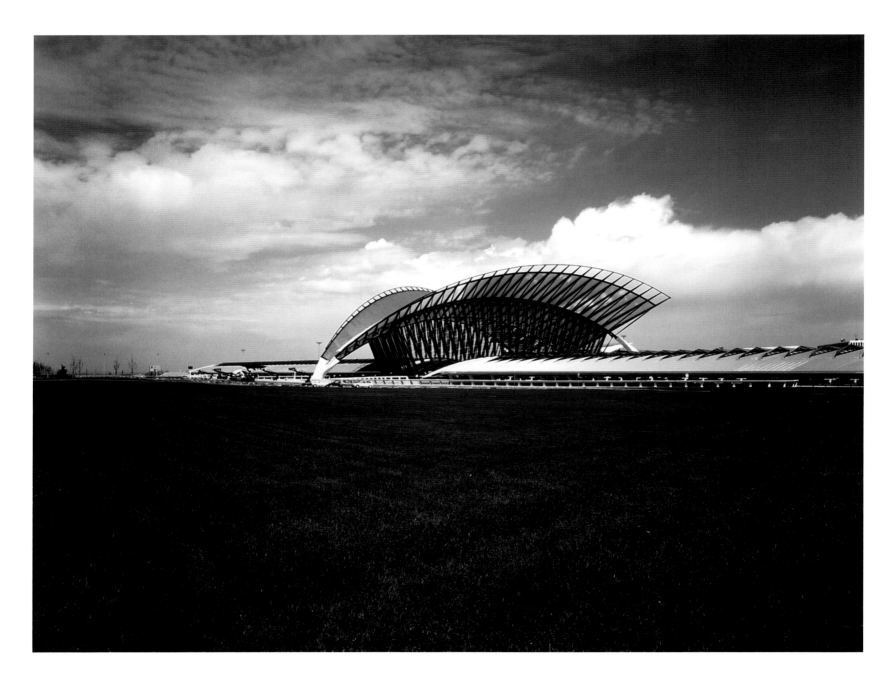

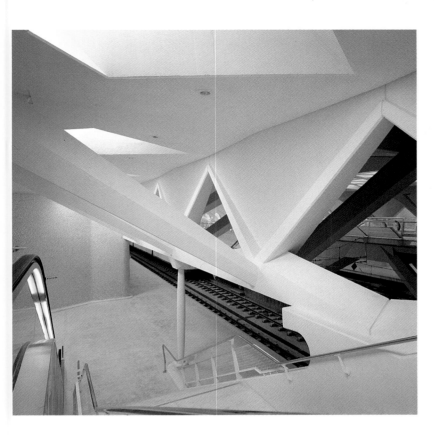

Valencia, 1996
Santiago Calatrava, Alameda Subway Station,
1991-95

Lyon Satolas, 1995
Santiago Calatrava, TGV Station, 1989-94

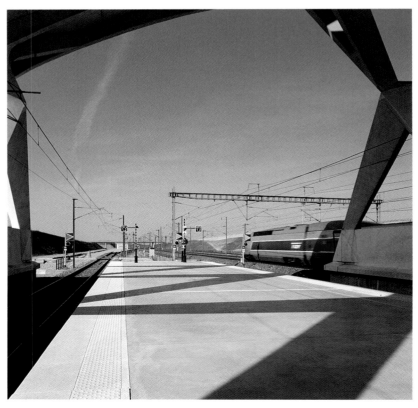

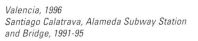

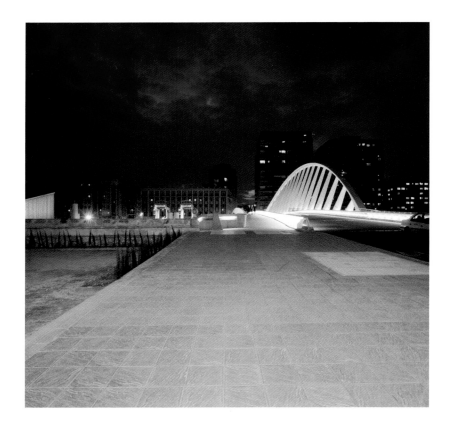

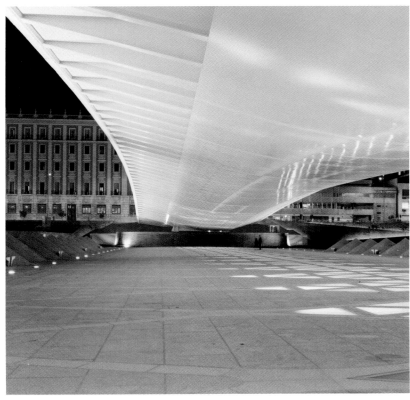

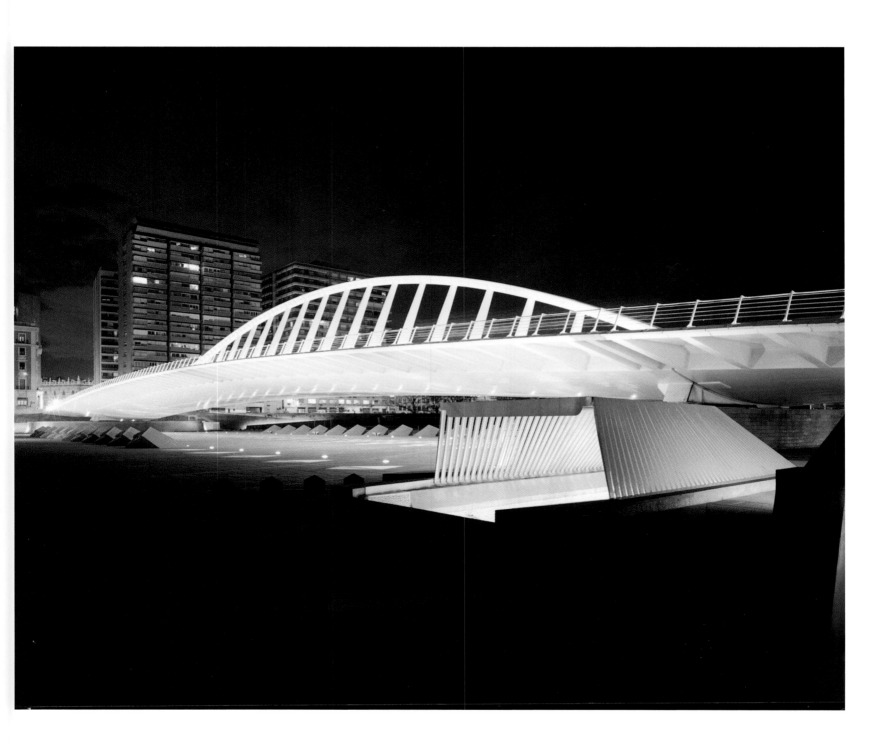

Ondarroa, 1995
Santiago Calatrava, Puerto Bridge, 1989-95

Sevilla, 1992
Santiago Calatrava, Alamillo Bridge, 1987-92

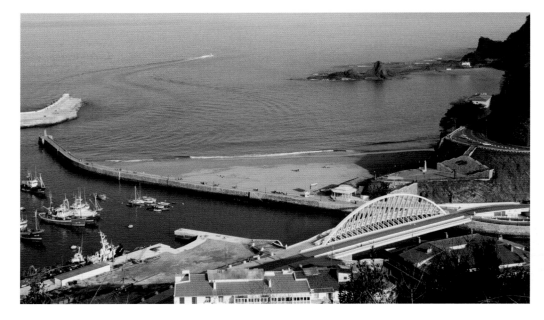

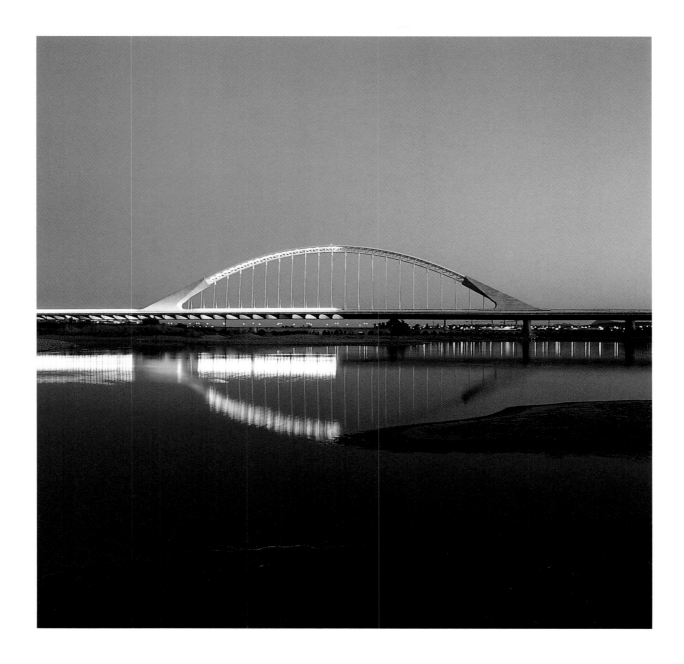

Valencia, 1996
Santiago Calatrava, Alameda Subway Station,
1991-95

Lisbon, 1998
Santiago Calatrava, Oriente Station, 1993-98

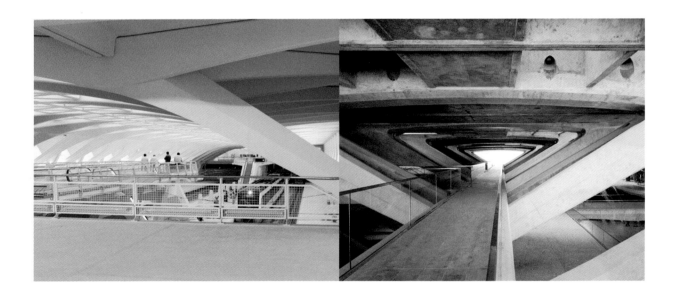

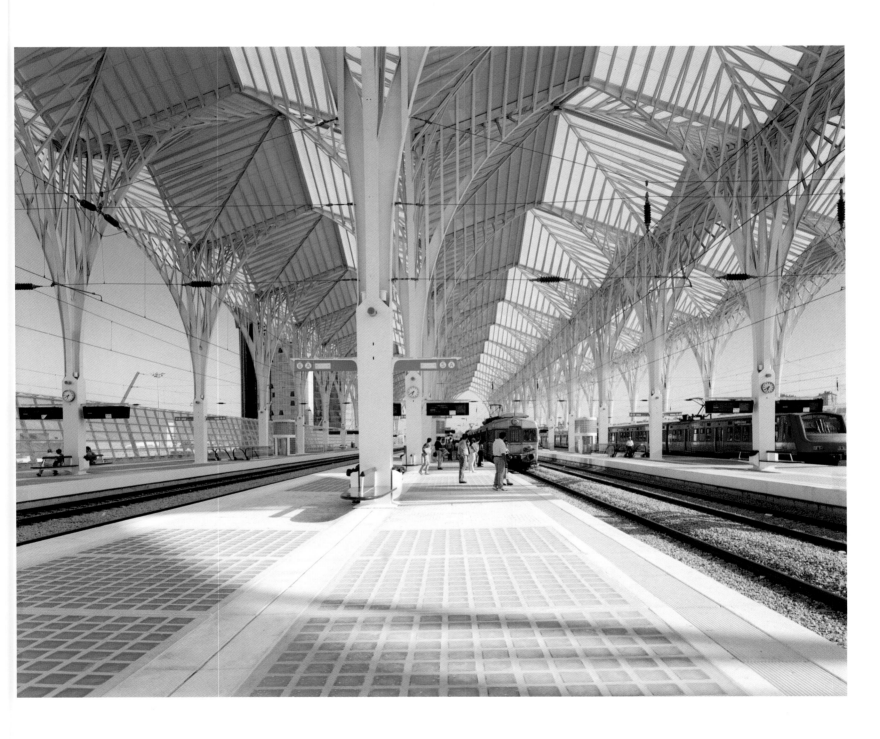

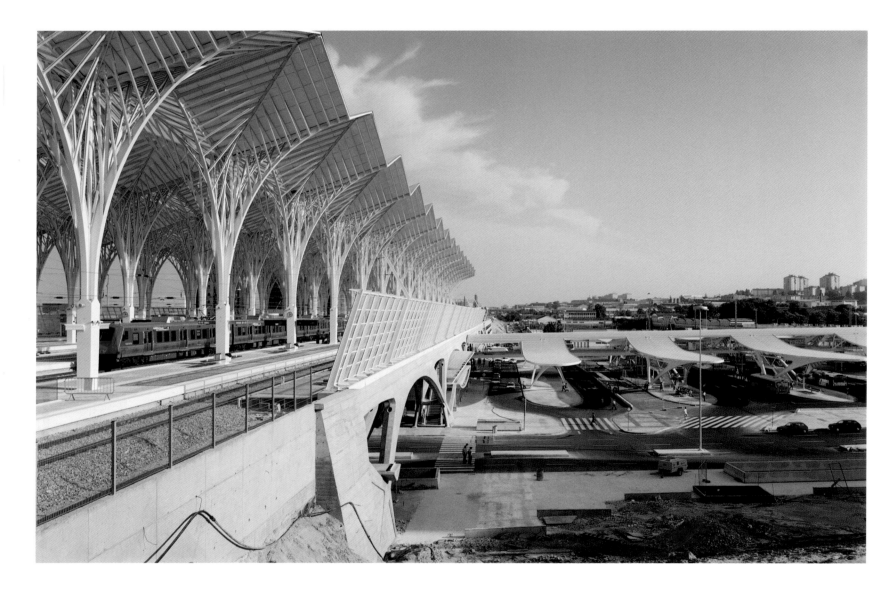

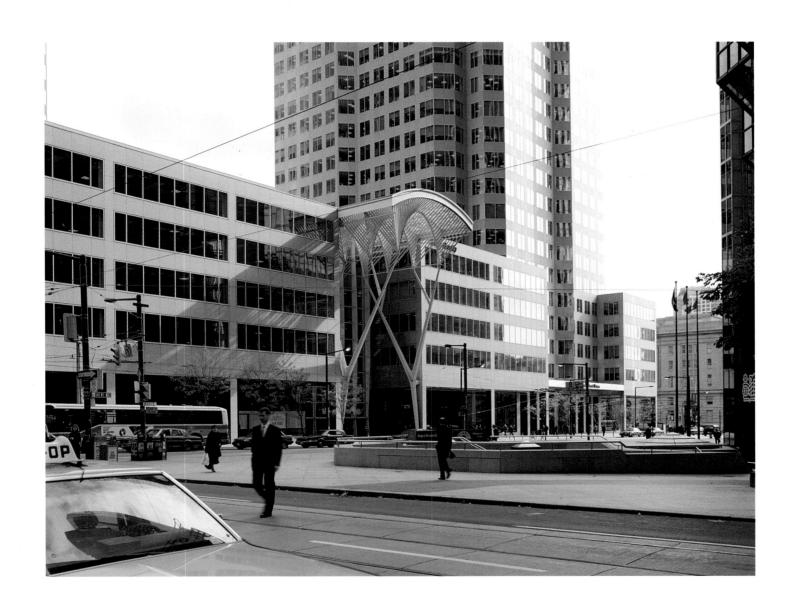

Lisbon, 1998
Santiago Calatrava, Oriente Station, 1993-98

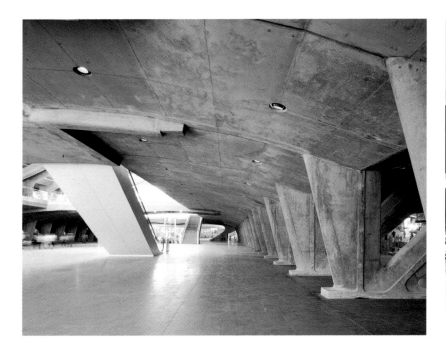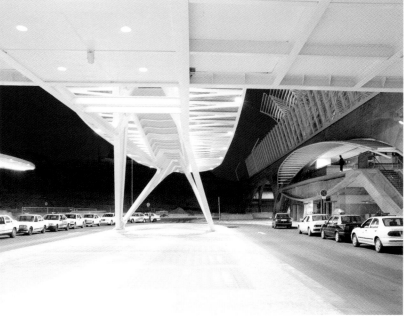

Lyon Satolas, 1995
Santiago Calatrava, TGV Station, 1989-94

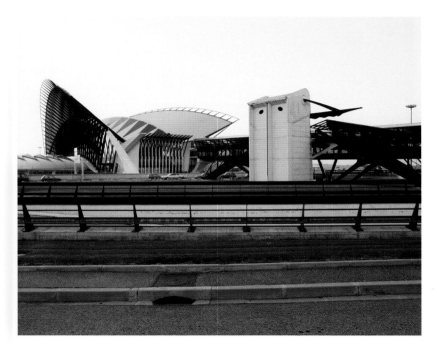 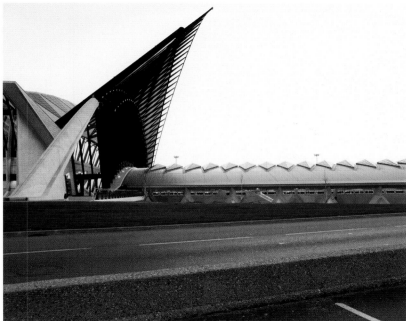

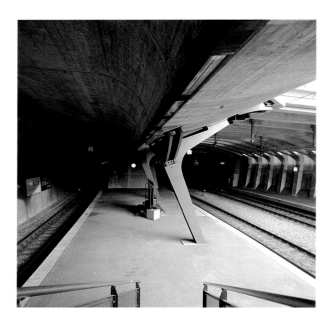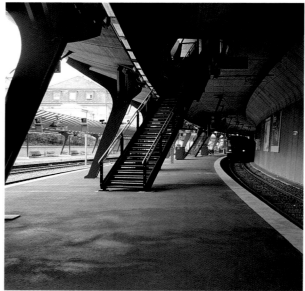

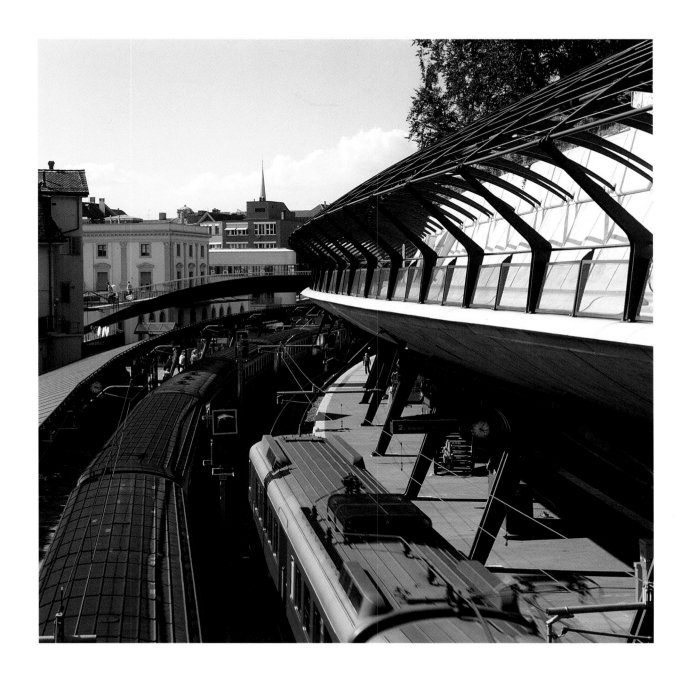

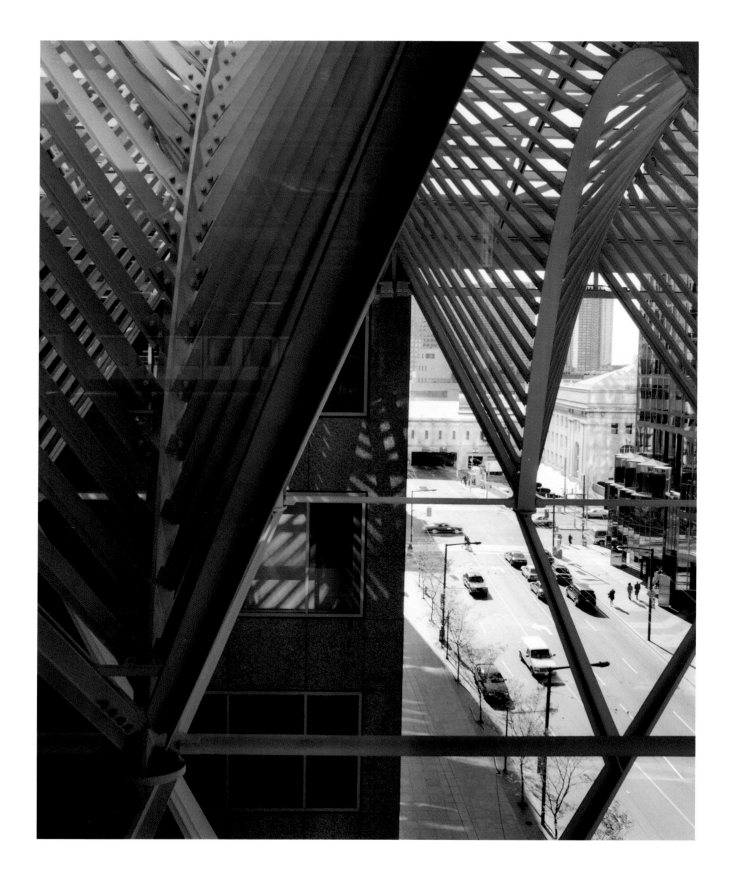

Toronto, 1993
Santiago Calatrava, BCE Gallery, 1987-92

Paris, 1993
Renzo Piano, House in Rue de Meaux, 1988-91

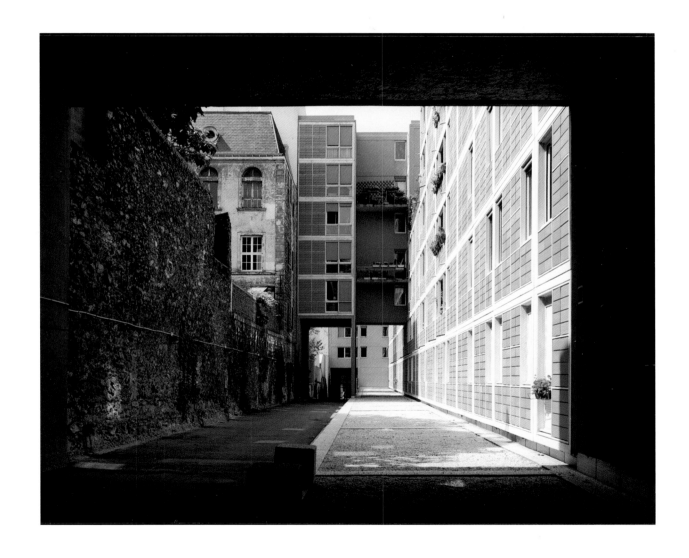

Paris, 1993
Renzo Piano, House in Rue de Meaux, 1988-91

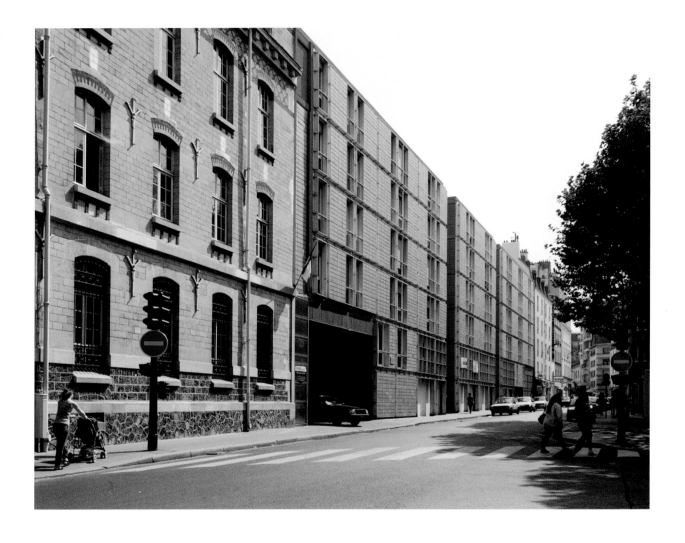

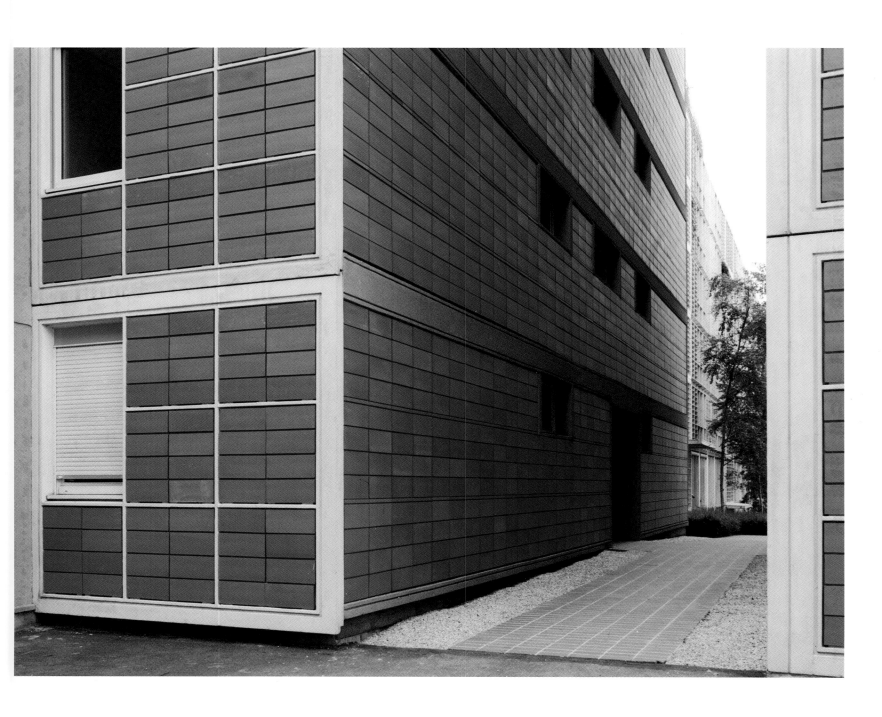

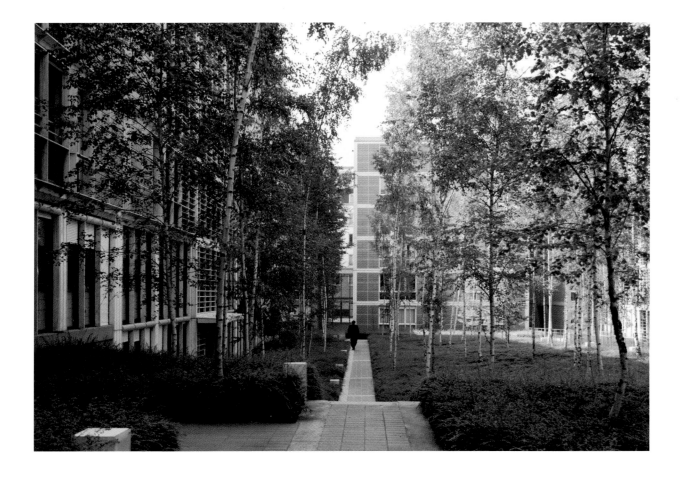

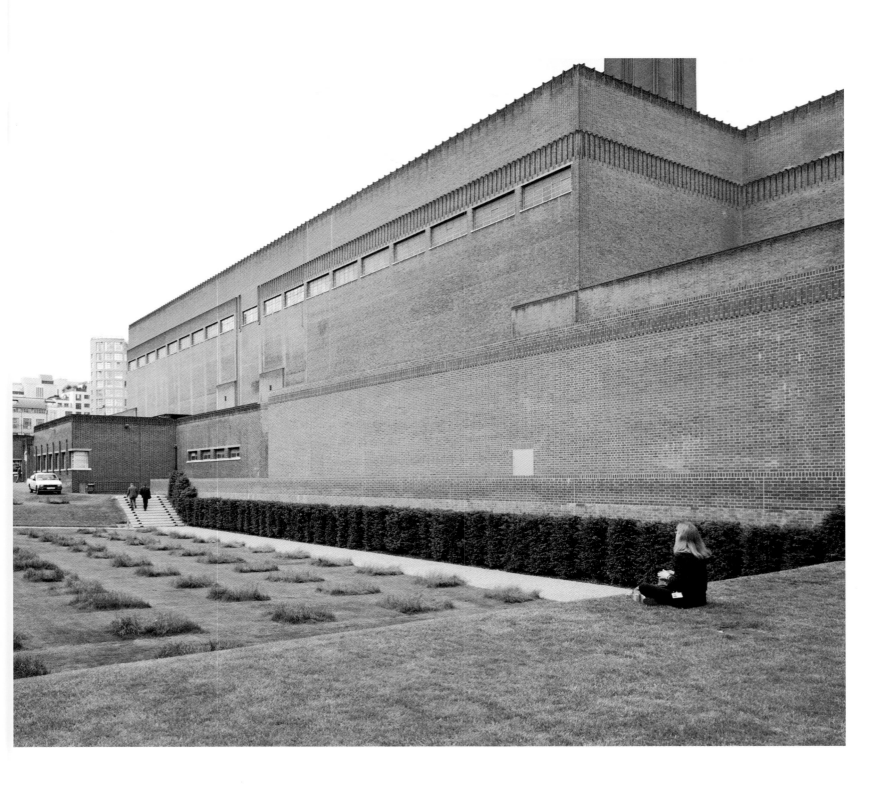

London, 2000
Herzog & De Meuron, Tate Modern, 2000

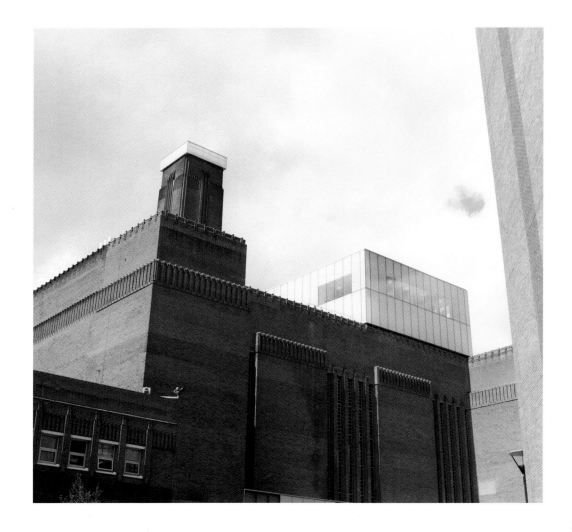

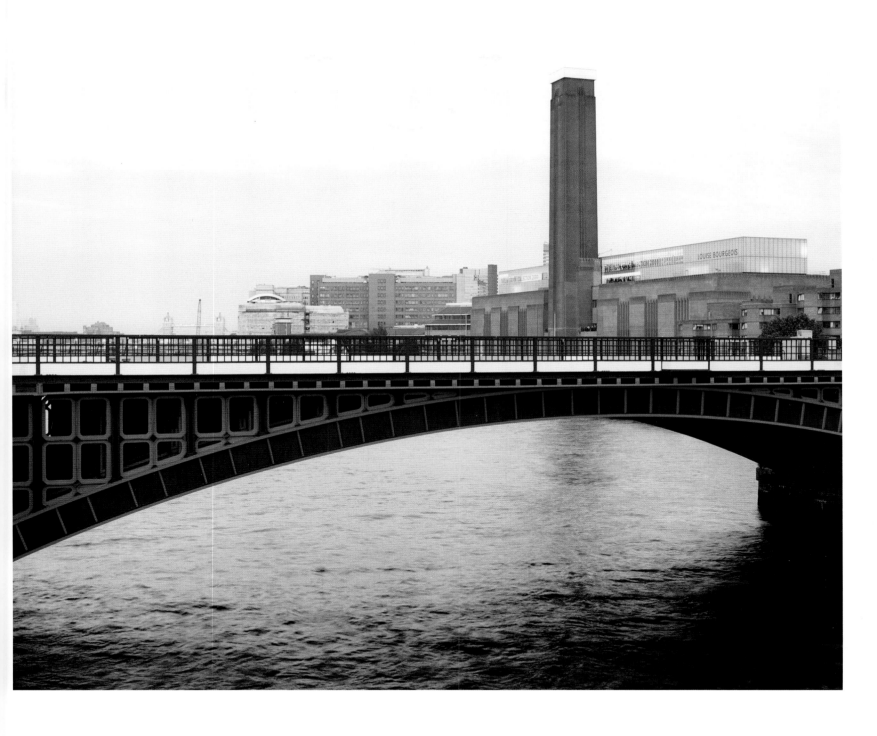

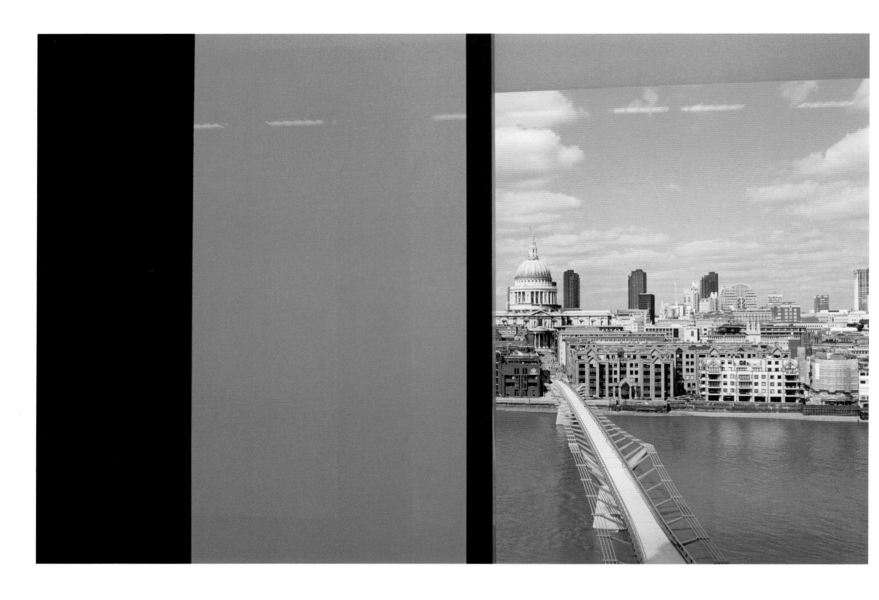

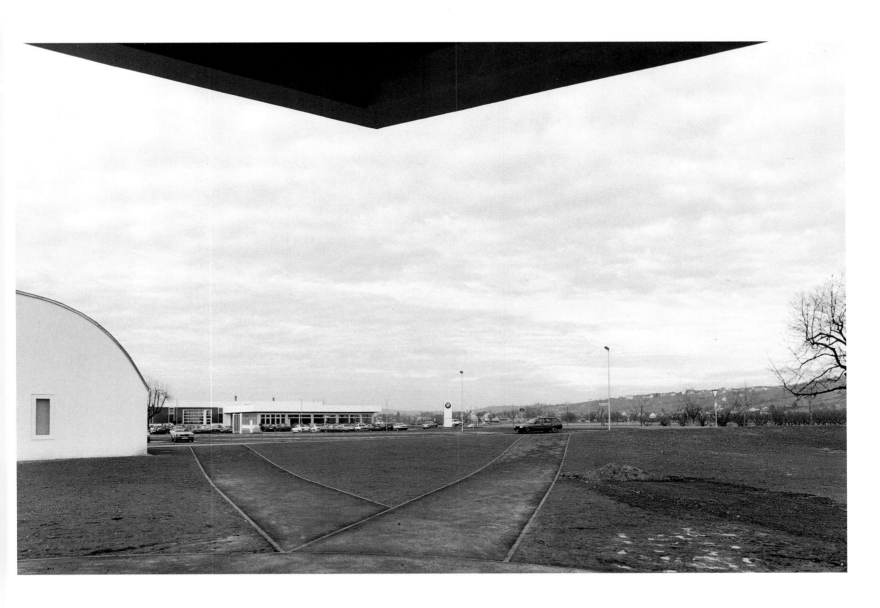

Weil Am Rhein, 1990
Frank O. Gehry, Vitra Museum, 1989

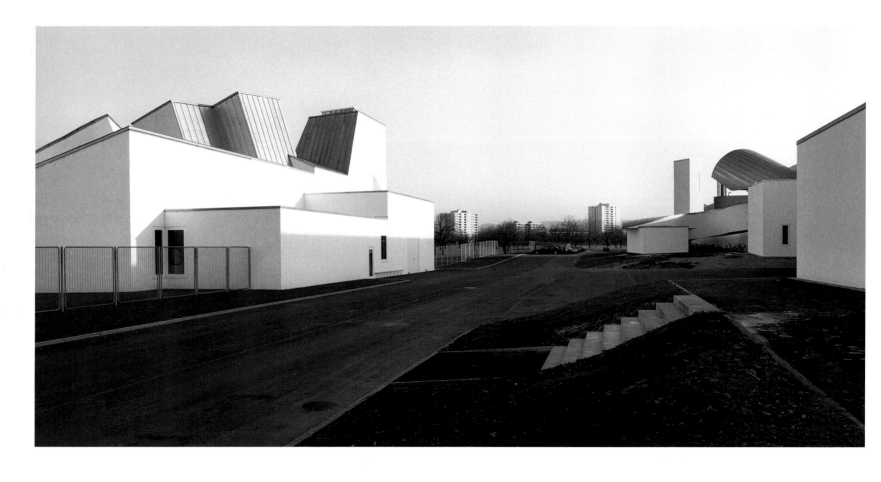

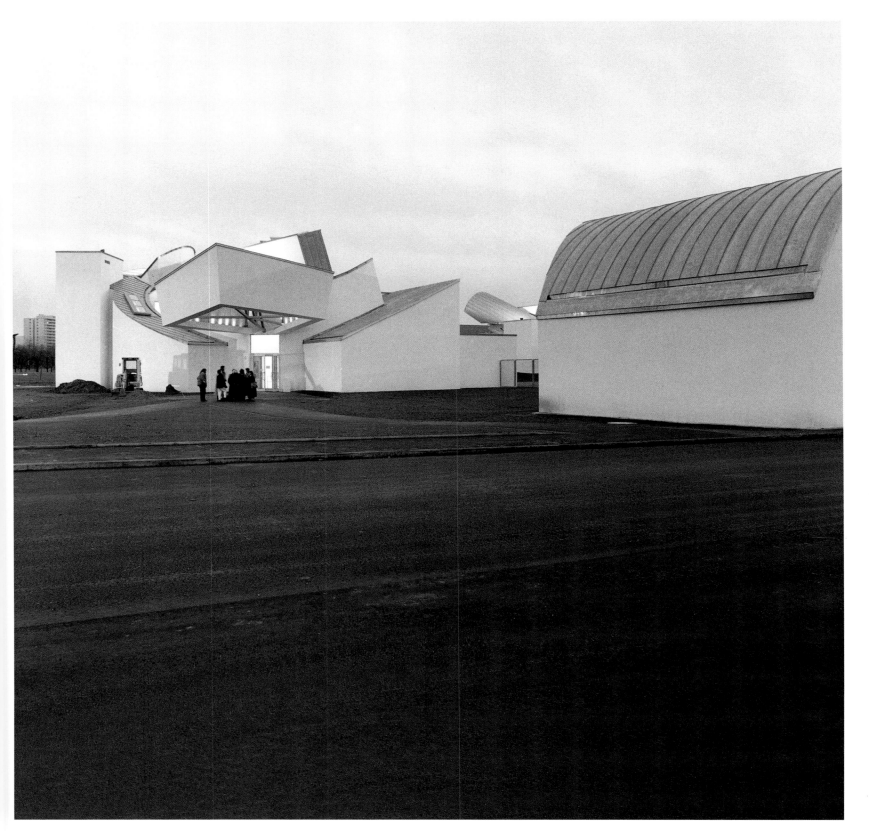

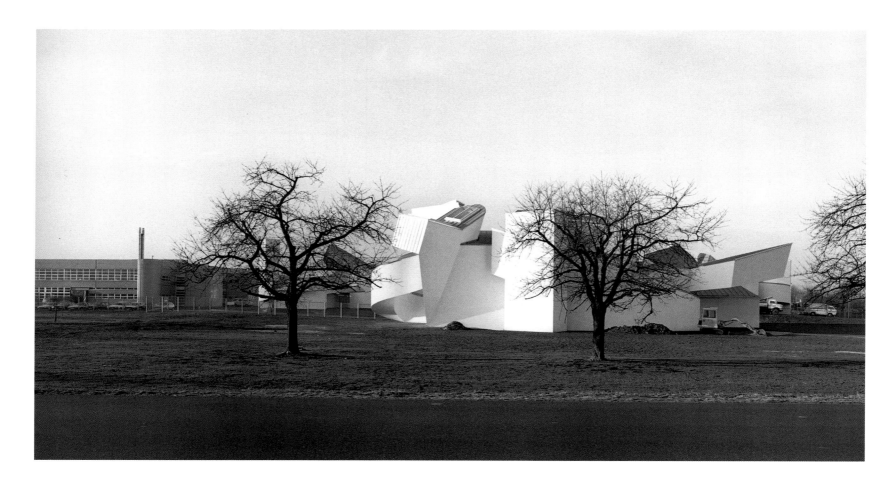

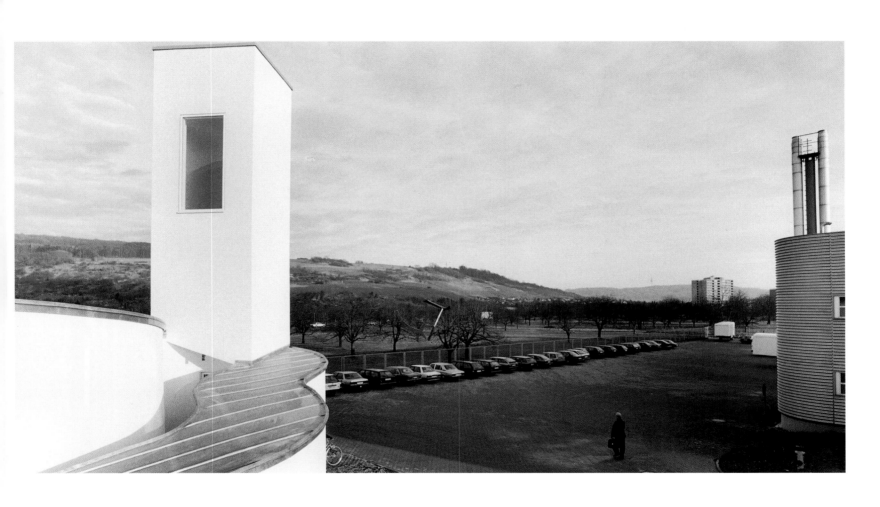

Weil Am Rhein, 1990
Frank O. Gehry, Vitra Museum, 1989

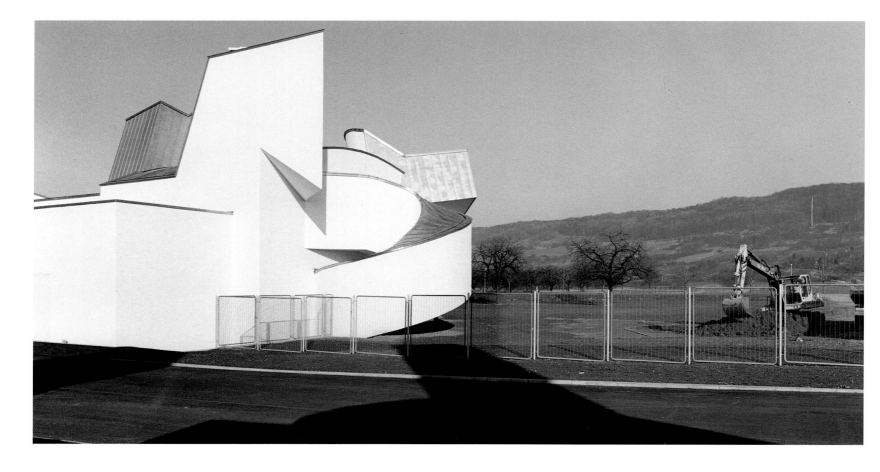

Basel, 1991
Herzog & De Meuron, Apartment Building
in Hebelstrasse, 1989-91

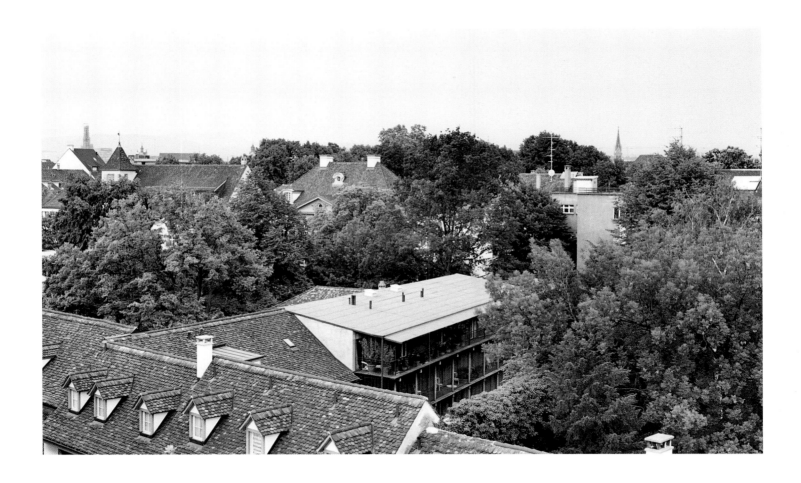

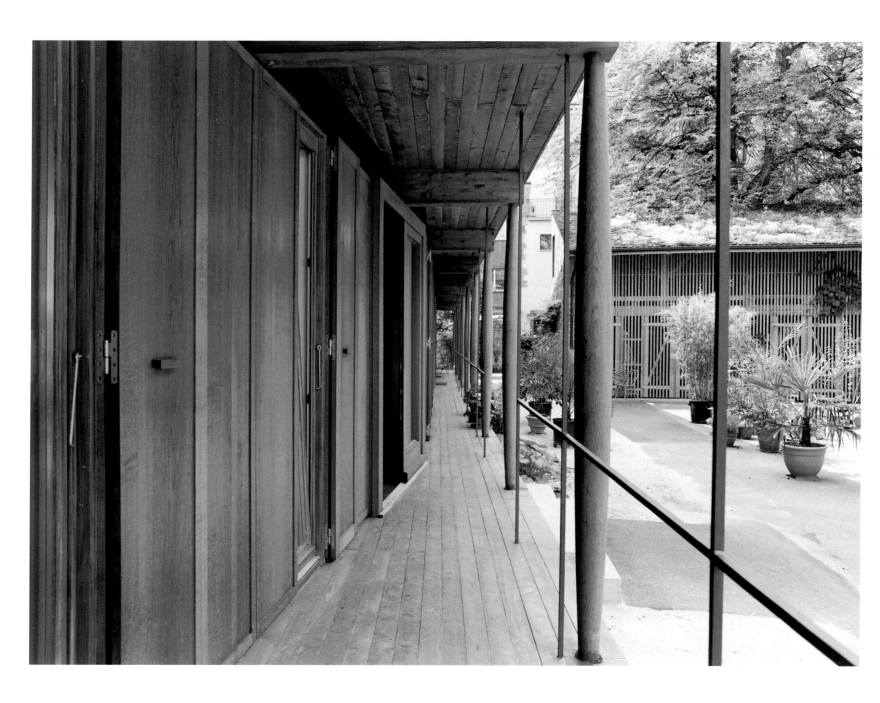

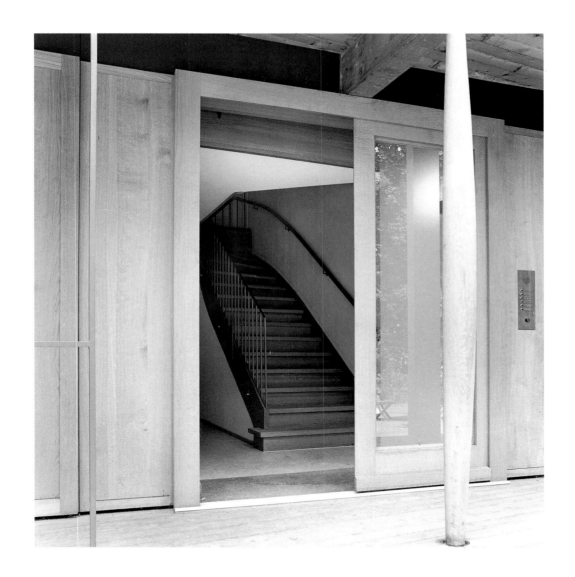

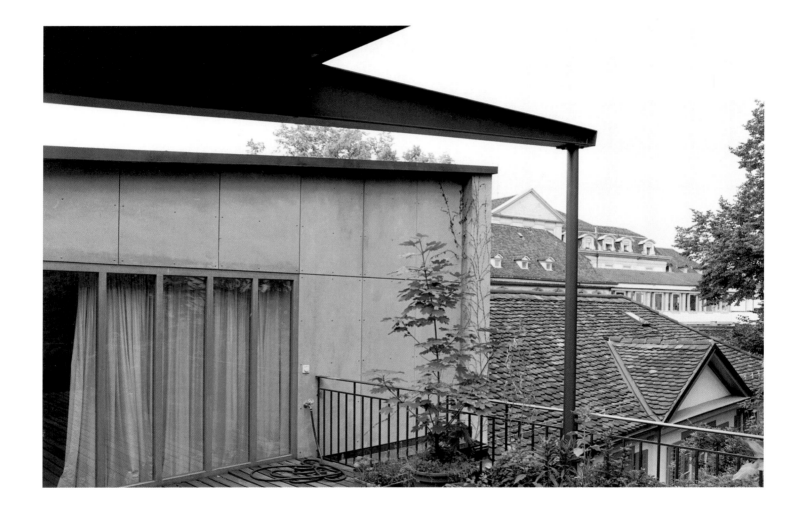

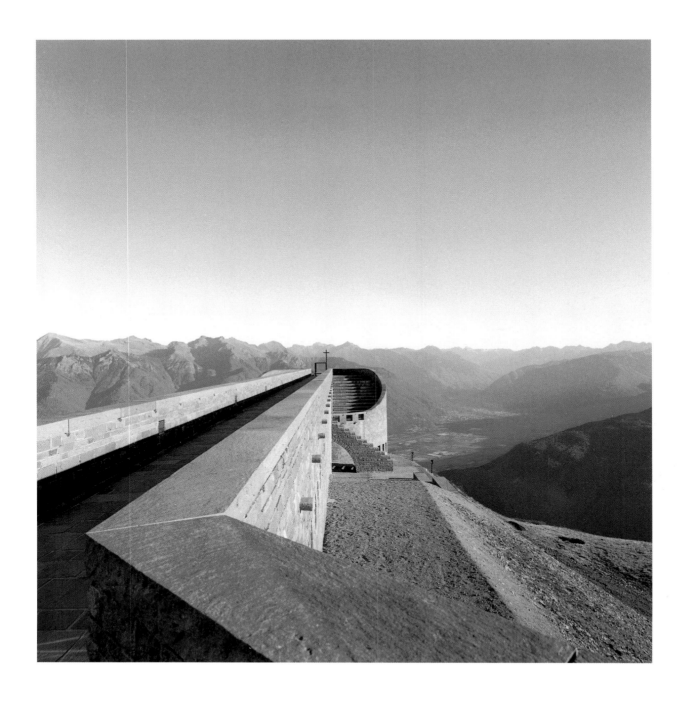

Monte Tamaro, 1996
Mario Botta, Santa Maria degli Angeli, 1992-95

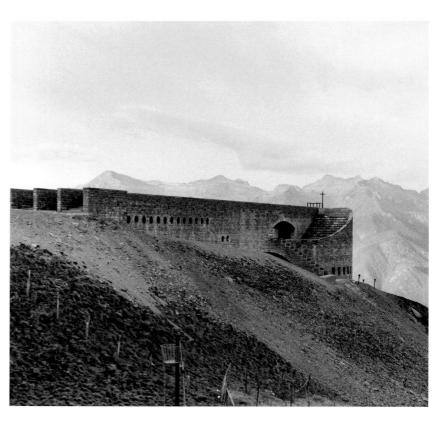

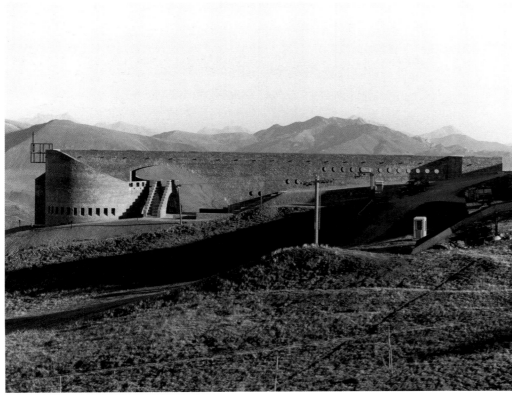

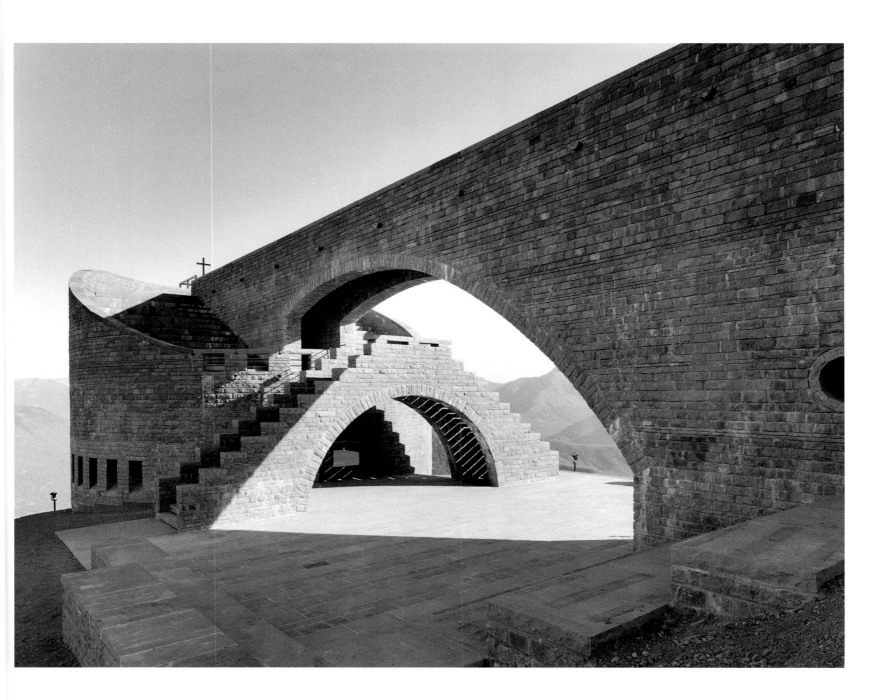

Monte Tamaro, 1996
Mario Botta, Santa Maria degli Angeli, 1992-95

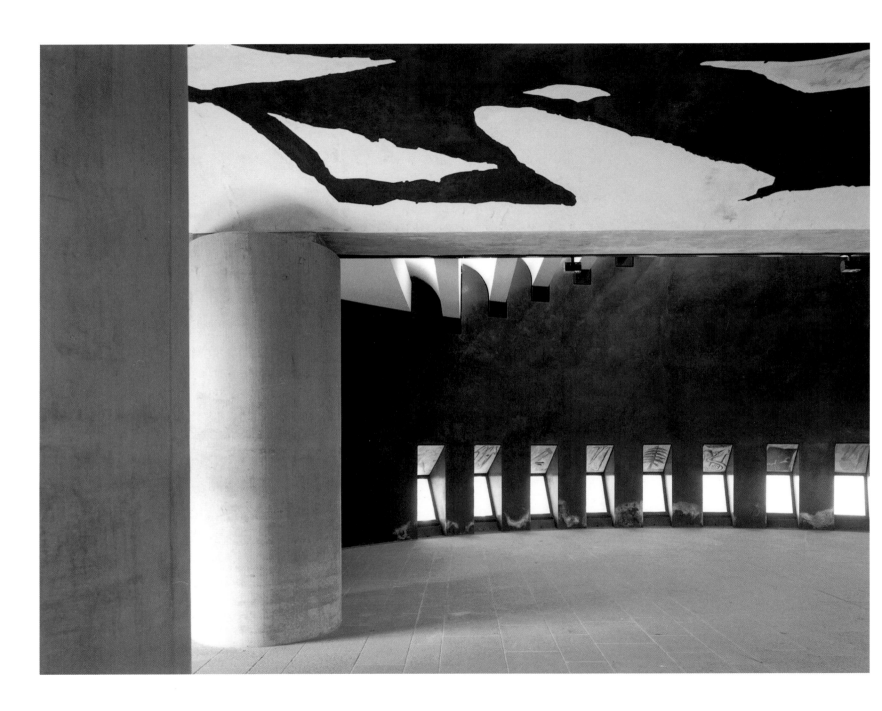

Sevilla, 1991
Cruz y Ortiz, Santa Justa Station, 1987-91

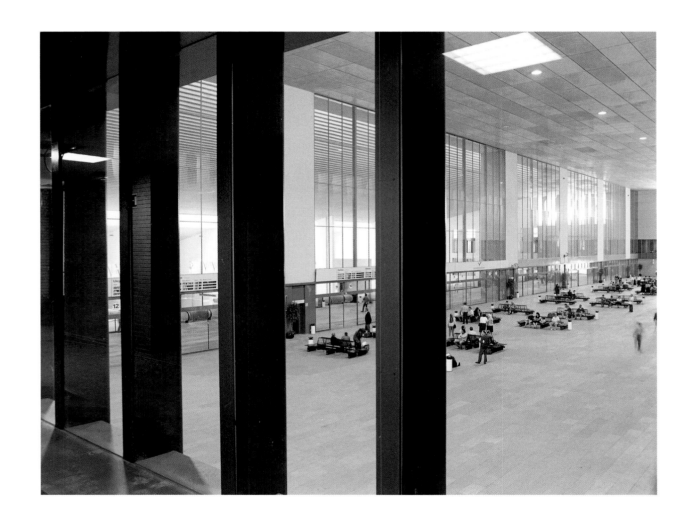

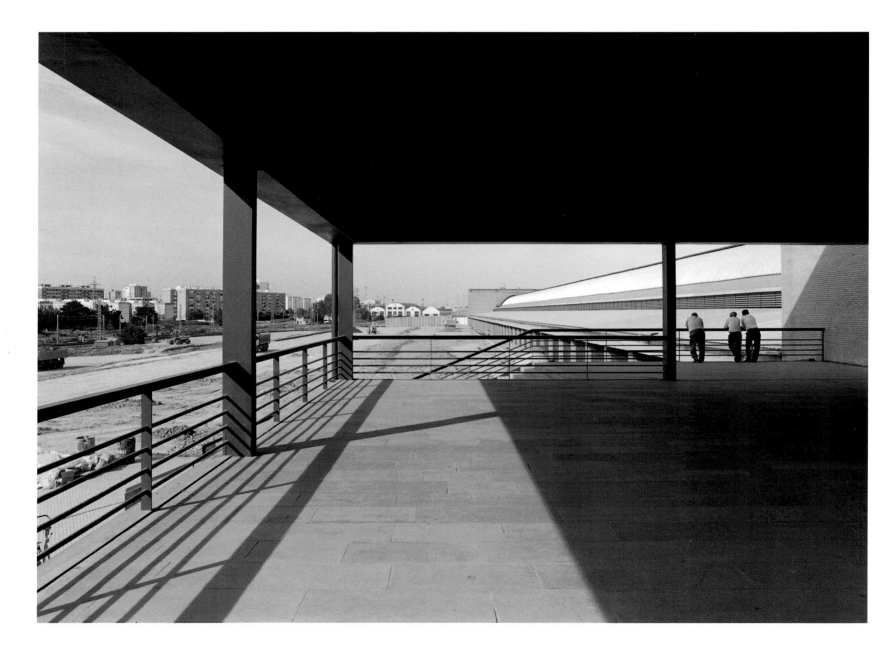

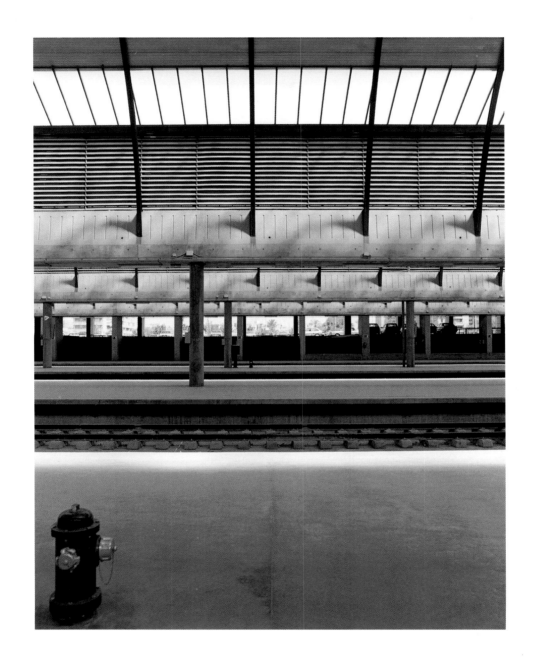

Sevilla, 1991
Cruz y Ortiz, Santa Justa Station, 1987-91

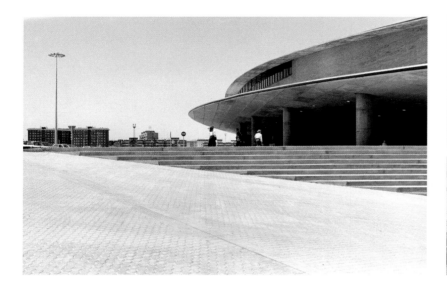

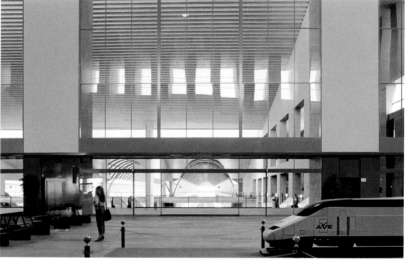

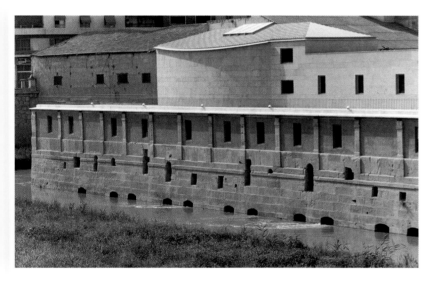
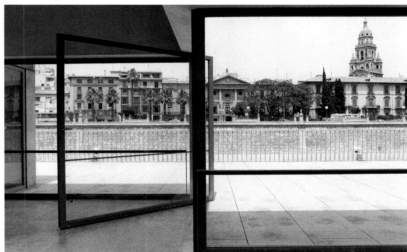

Madrid, 1987
Juan Navarro Baldeweg, Social Centre,
Puerta de Toledo, 1987

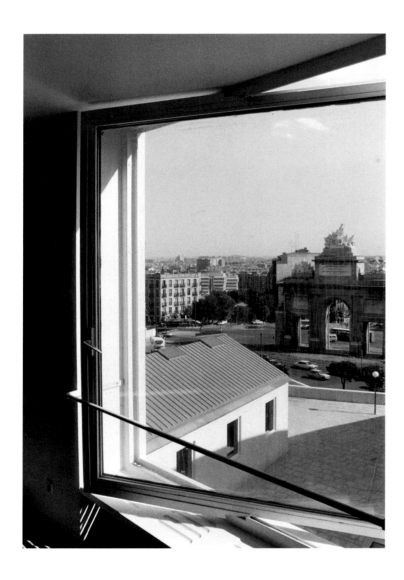

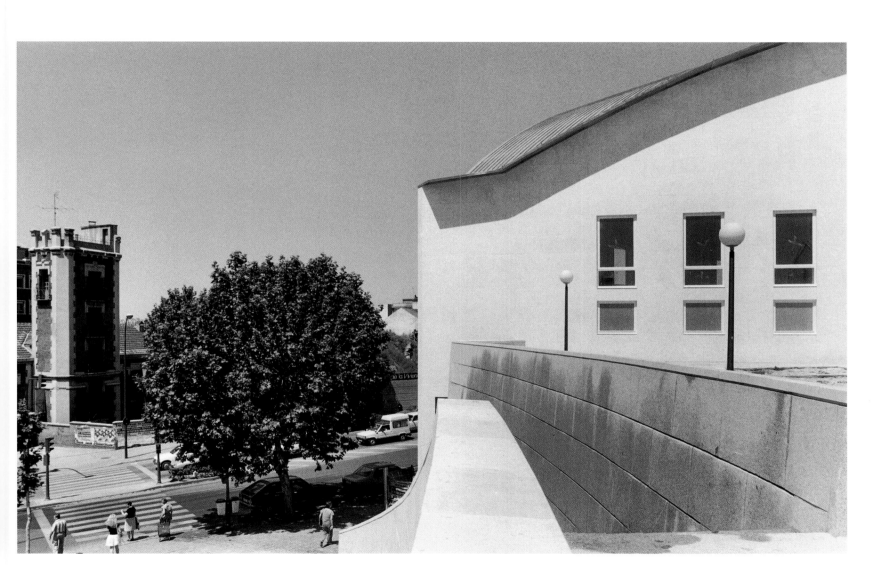

Murcia, 1987
Juan Navarro Baldeweg, Murcia Mills, 1986

Salamanca, 1992
*Juan Navarro Baldeweg, Convention Building,
1990-92*

Murcia, 1987
Juan Navarro Baldeweg, Murcia Mills, 1986

Madrid, 1987
*Juan Navarro Baldeweg, Social Centre,
Puerta de Toledo, 1987*

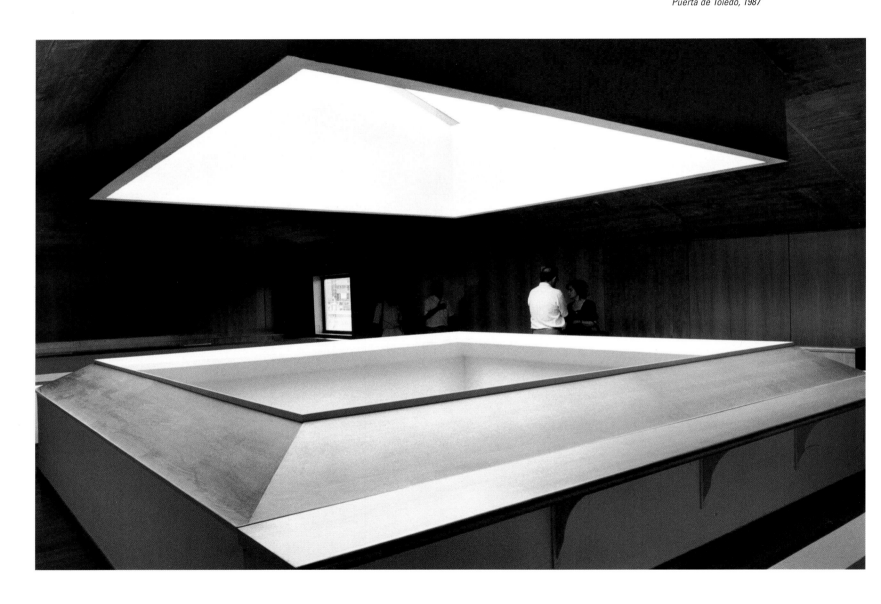

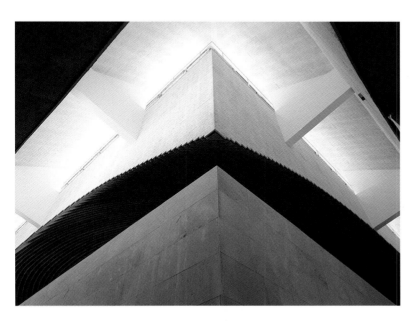

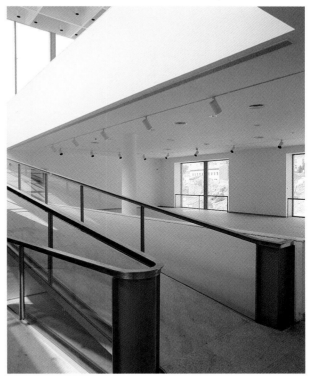

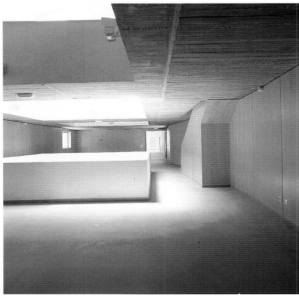

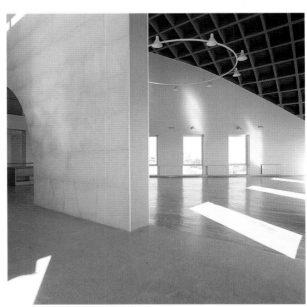

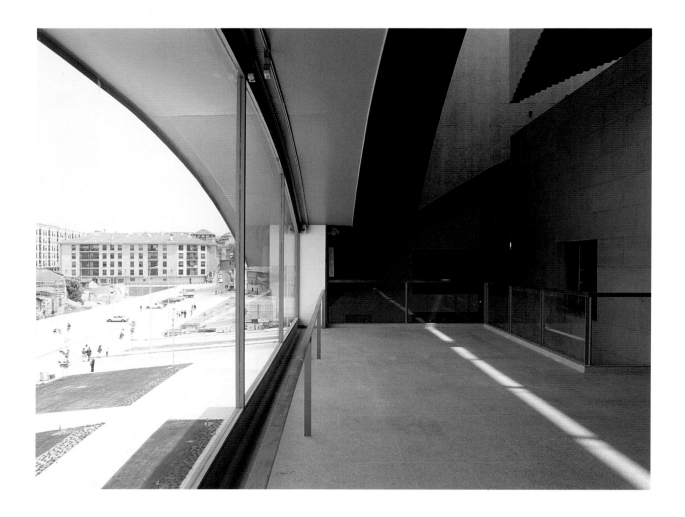

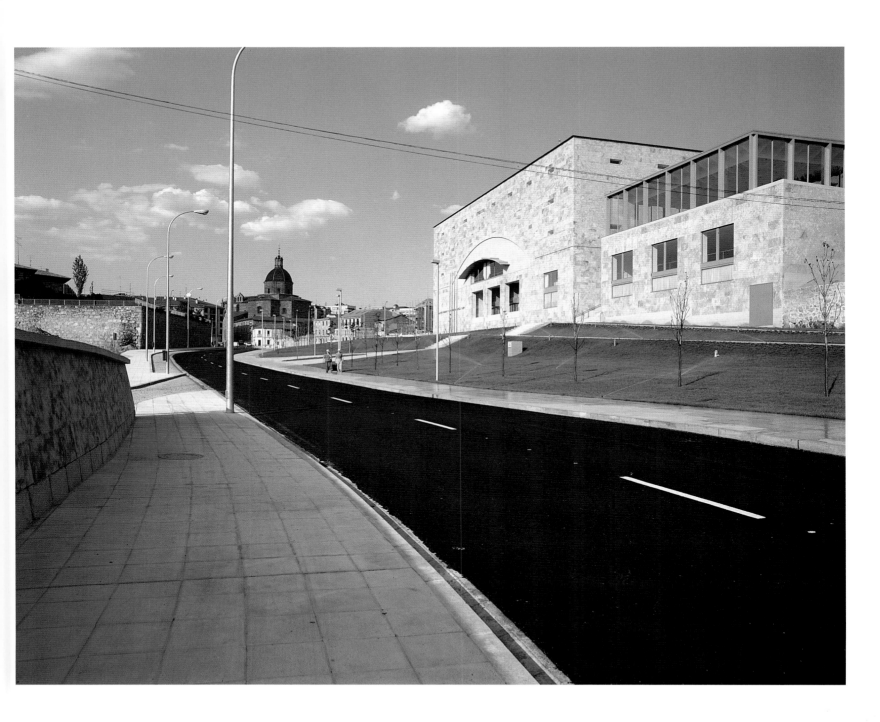

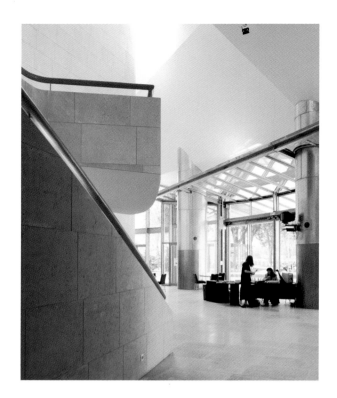

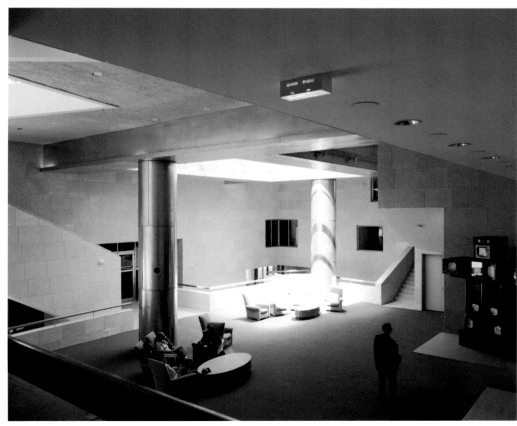

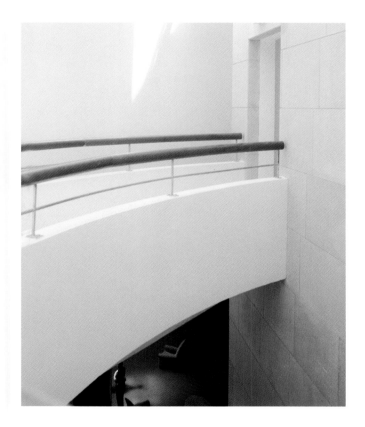

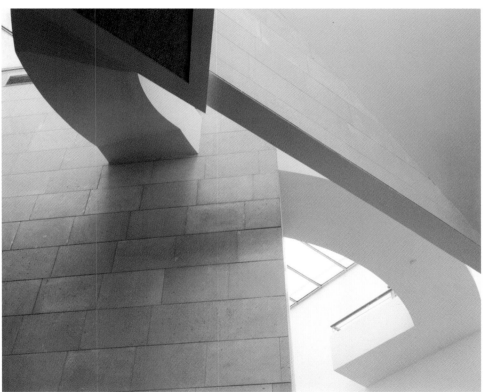

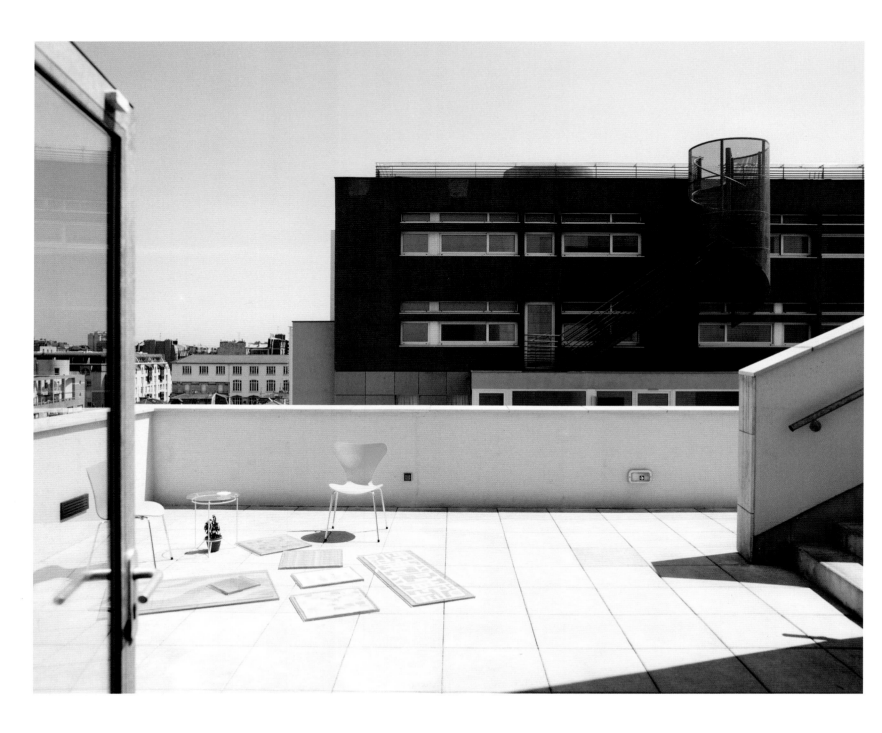

Luton, 1997
Ian Hamilton Finlay, Stockwood Park, 1986-91

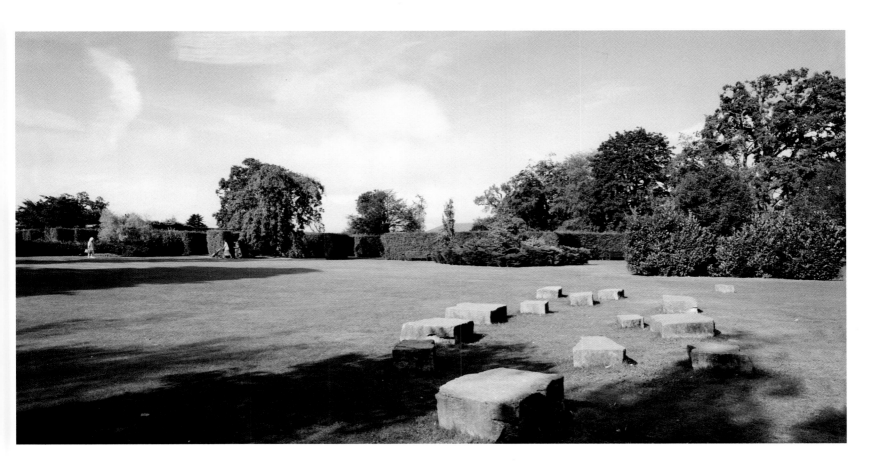

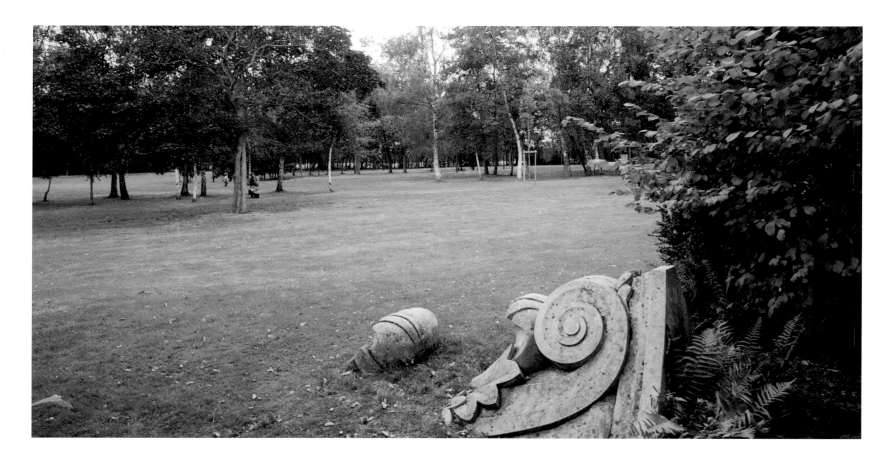

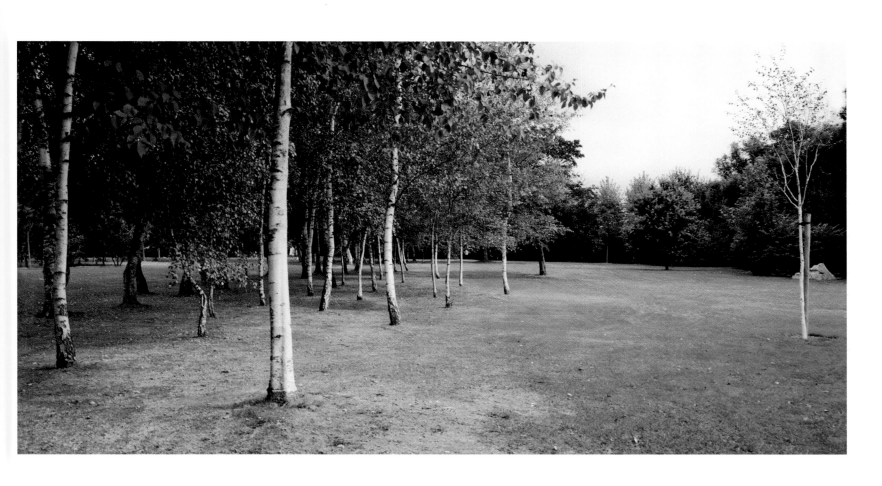

Luton, 1997
Ian Hamilton Finlay, Stockwood Park, 1986-91

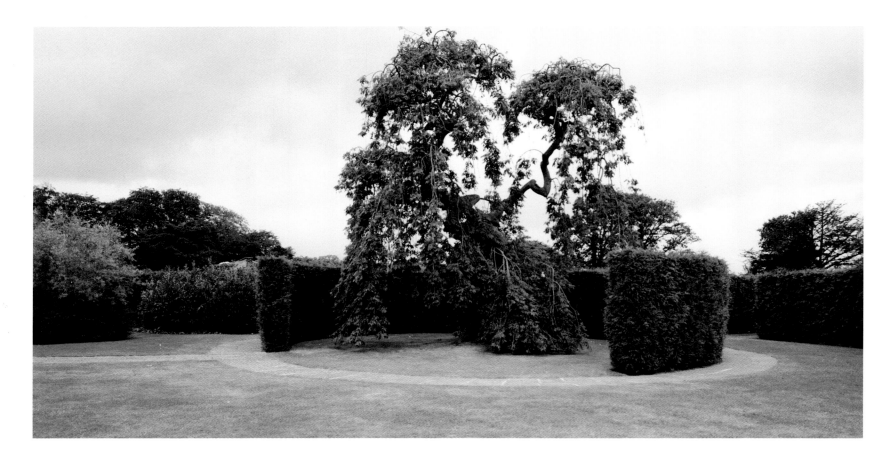

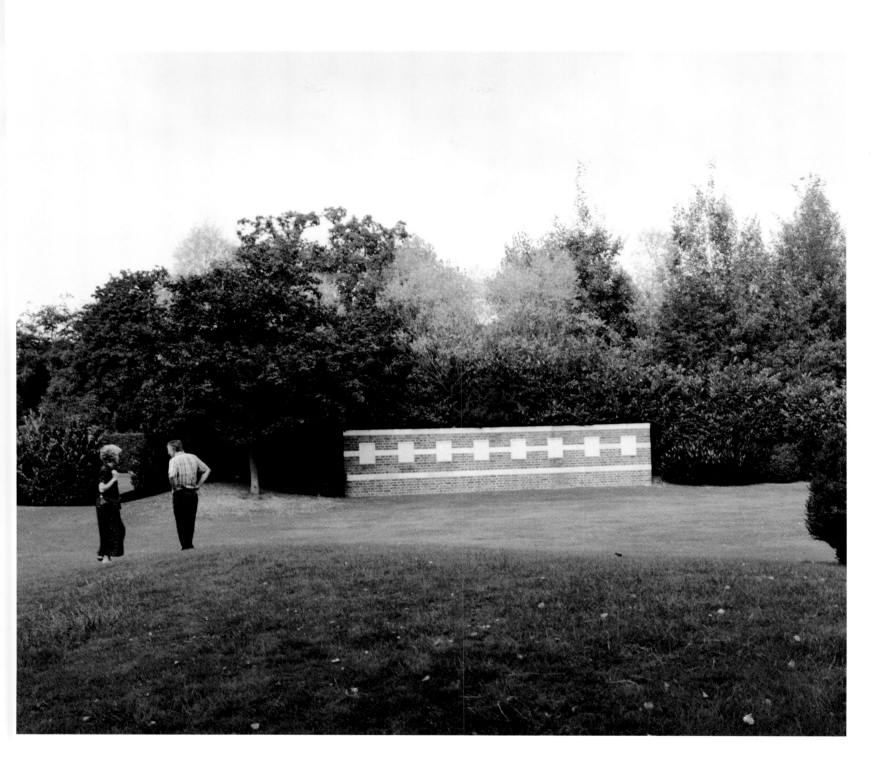

Florence, 1996
Arata Isozaki, Fashion Biennial, 1996

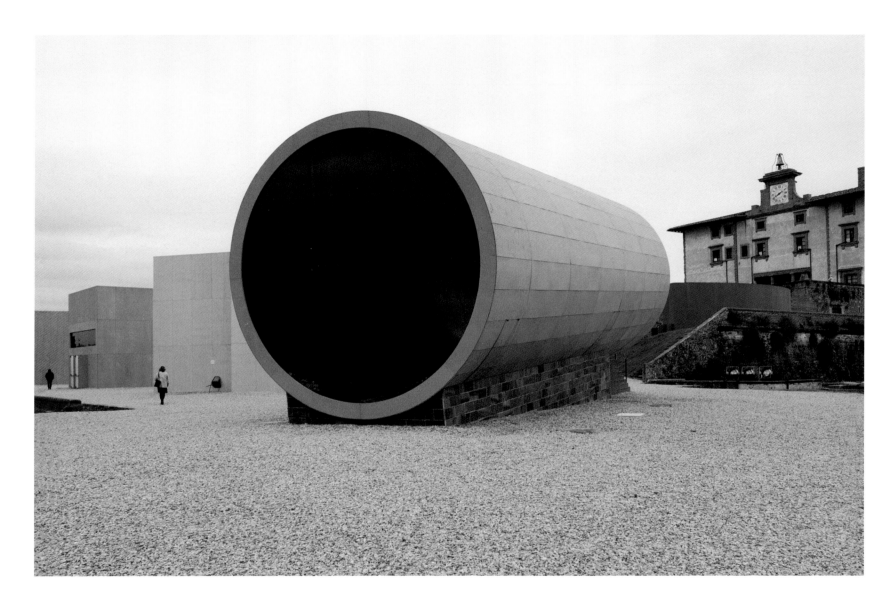

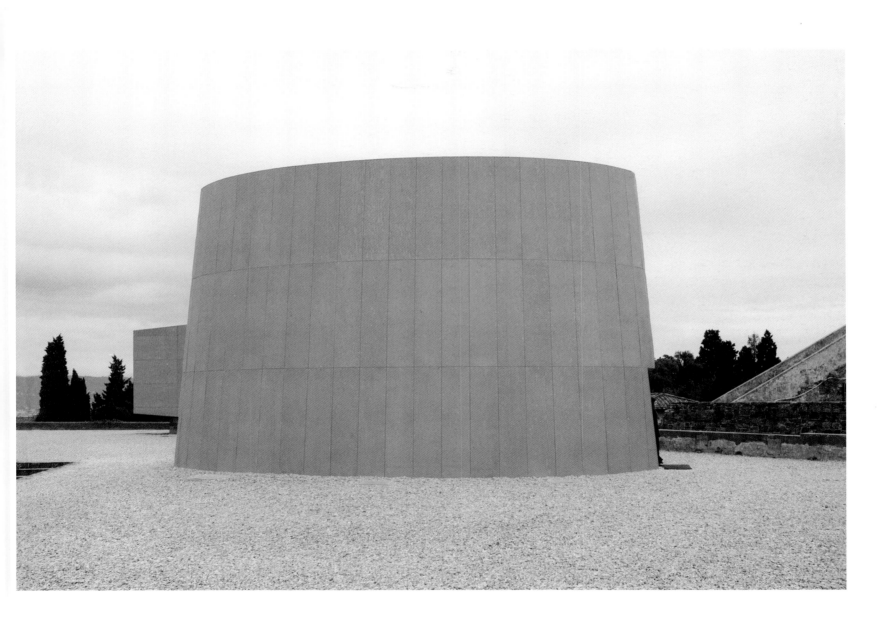

Florence, 1996
Arata Isozaki, Fashion Biennial, 1996

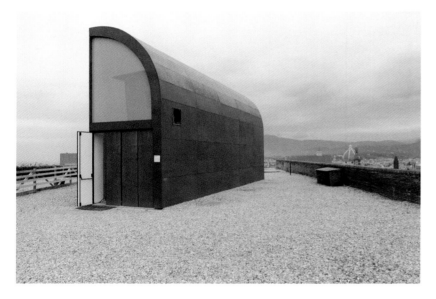

Milan, 2001
O.M.A. / Herzog & De Meuron, Exhibition,
Fondazione Prada, 2001

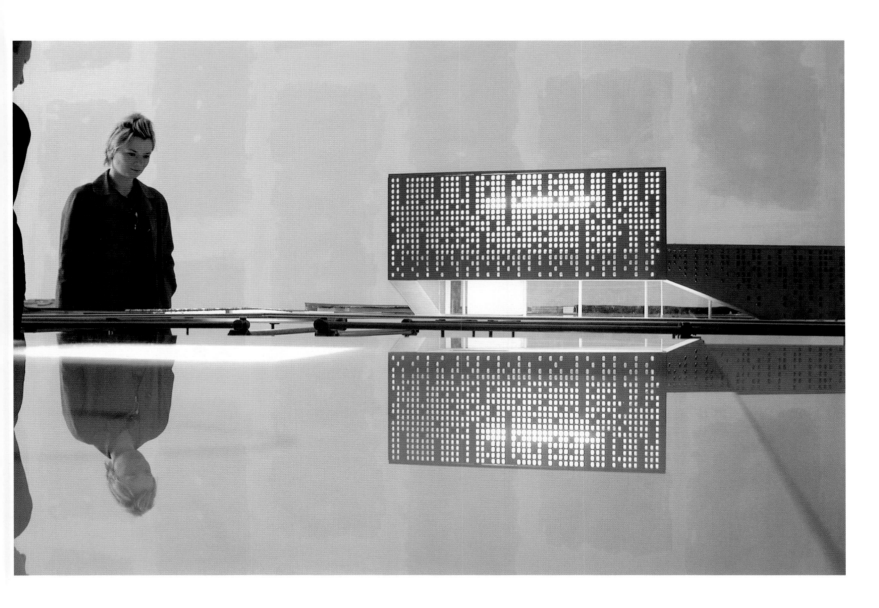

Corseaux, 1989
Le Corbusier, Petite Maison, 1923

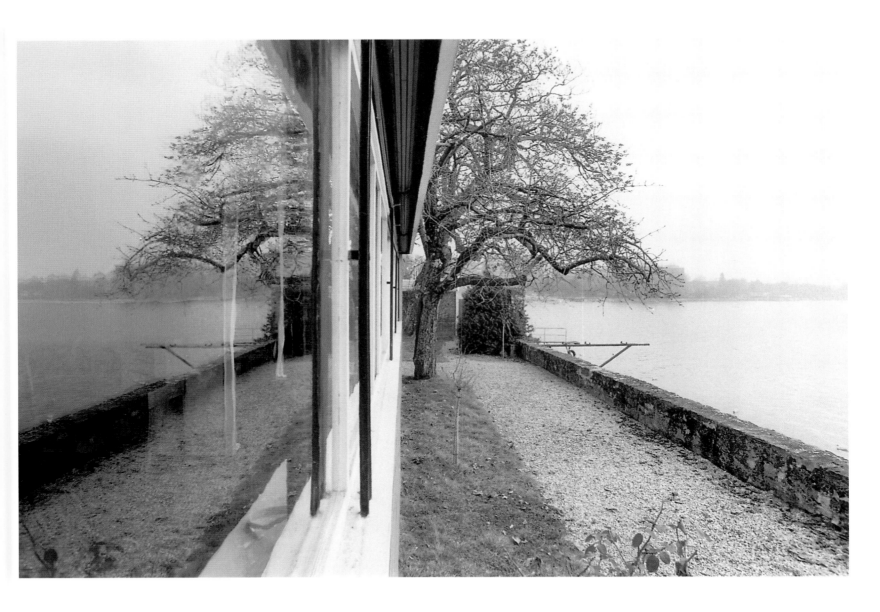

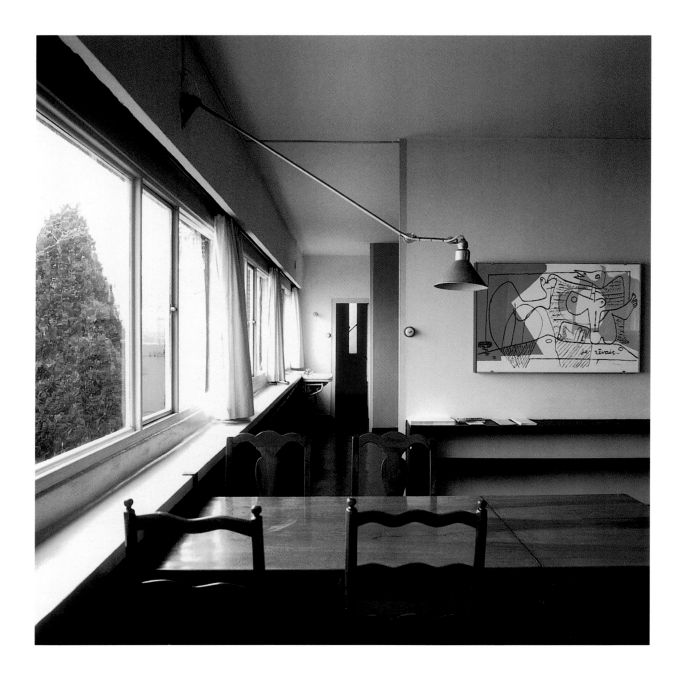

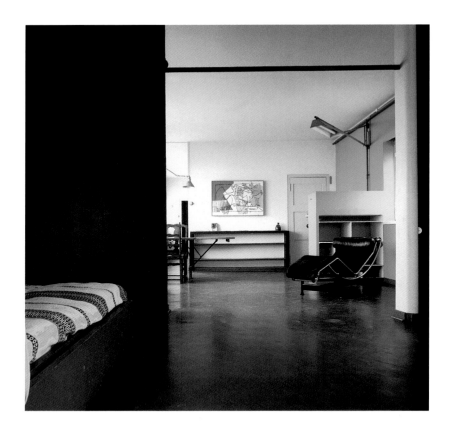

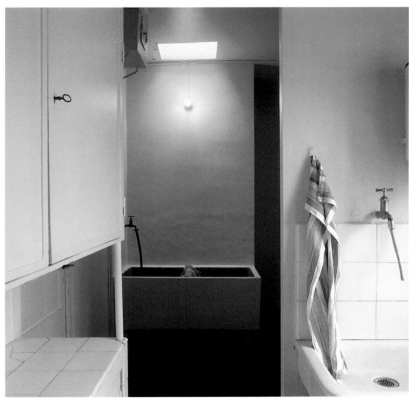

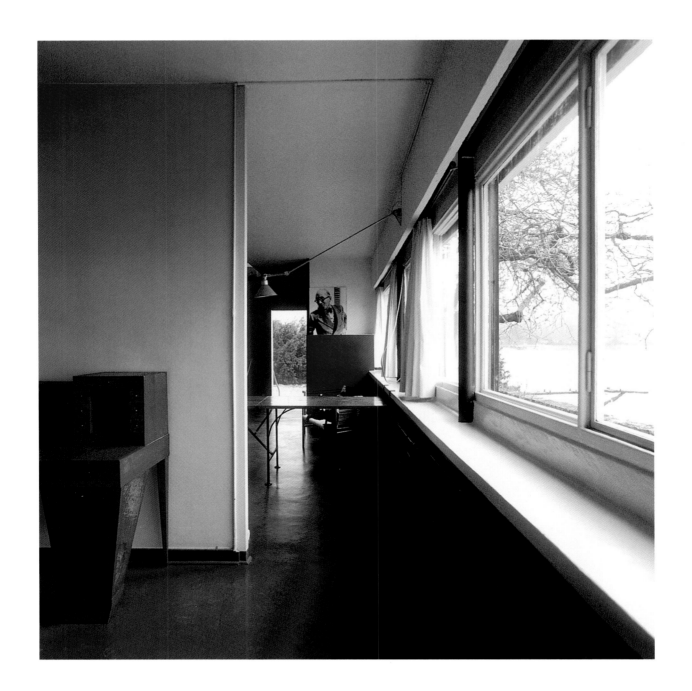

Corseaux, 1989
Le Corbusier, Petite Maison, 1923

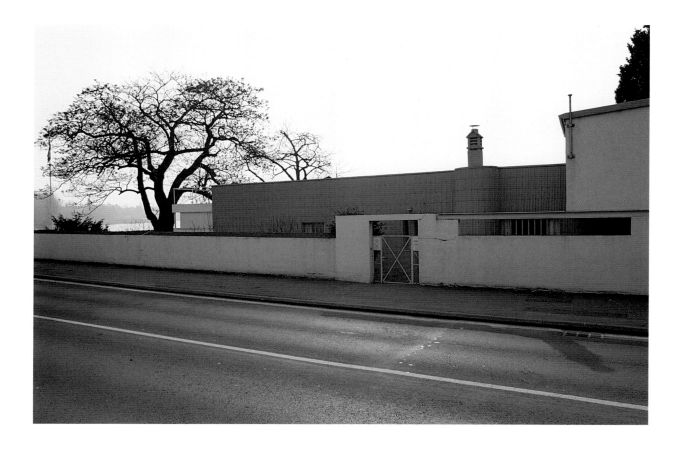

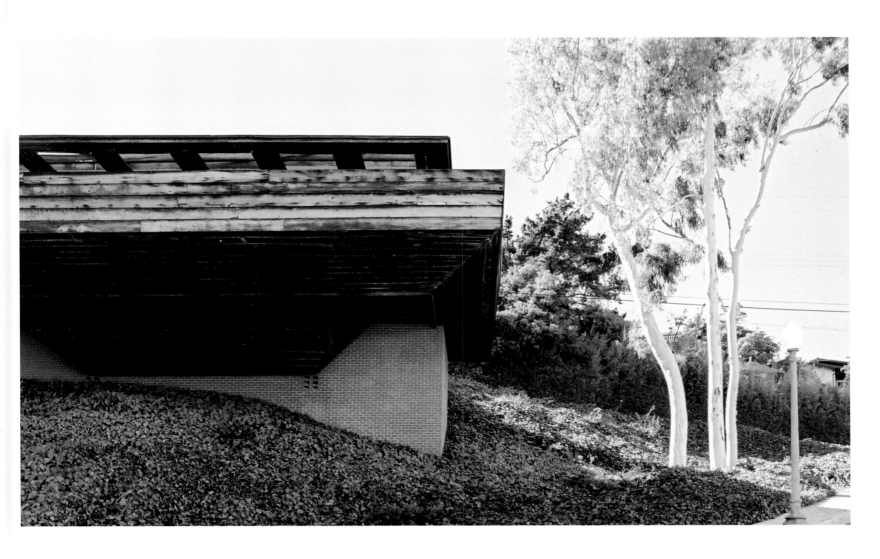

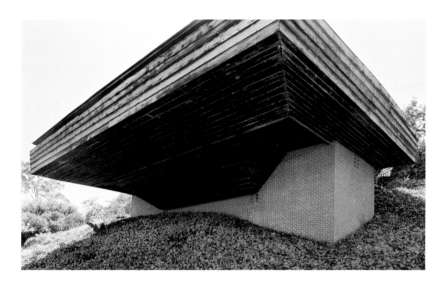

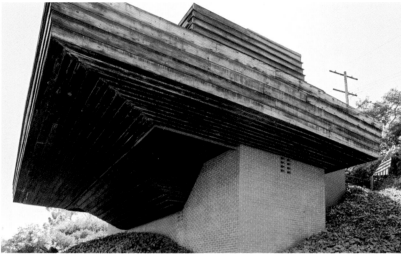

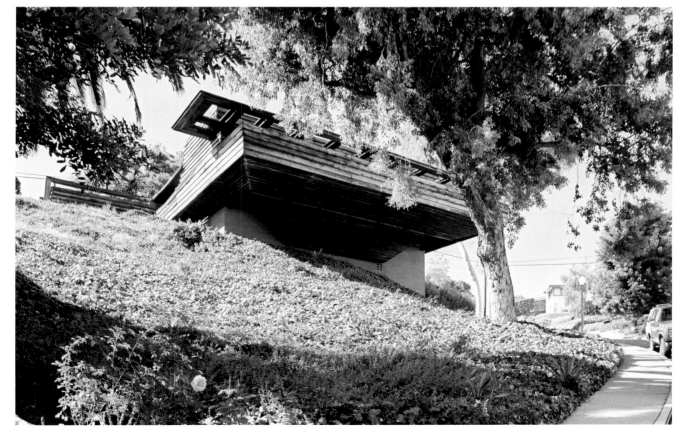

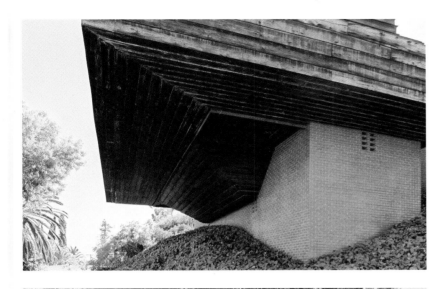

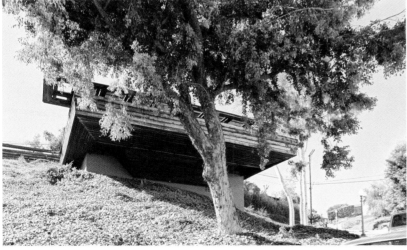

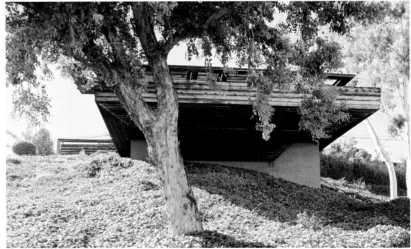

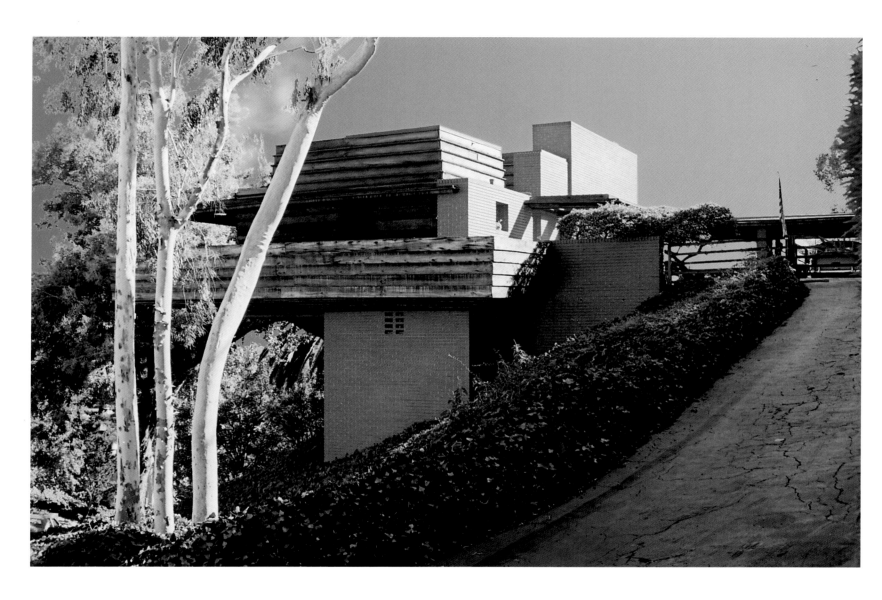

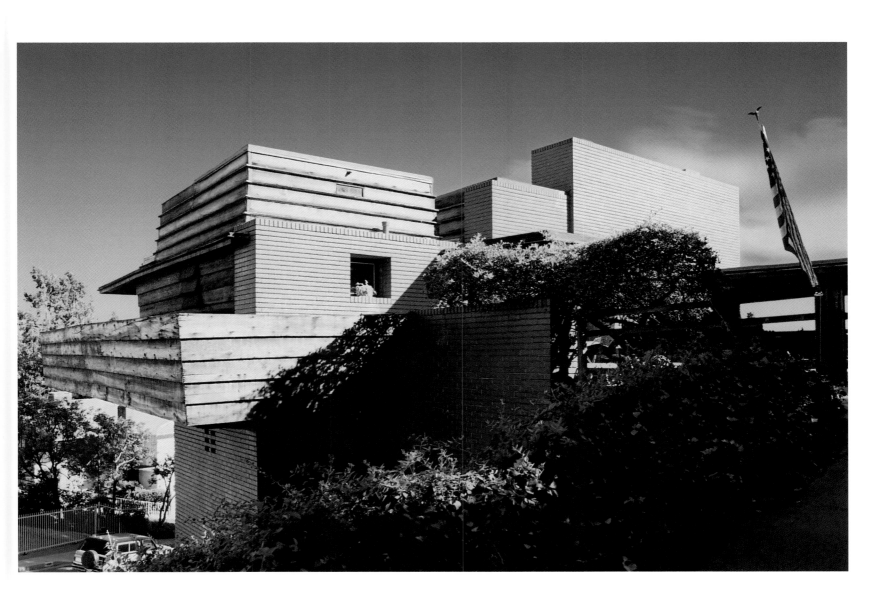

Seeing Architecture

The photographs in this book refer to a long period of my activity as photographer. If I try to find a beginning or my first contact with Modern architecture as work I must go back to a visit I made to Chandigarh some 20 years ago, while returning from an extensive study of Indian temples. The emancipation, the farewell to a purely theoretical architecture and the passage to the problem of visual reconstruction were resolved in a matter of hours and a certain number of rolls, with a wide-angle that scrutinized this open, luminous city, portrayed in books through sharp, contrasted photos but already then more fragile, dust-laden and consumed by the Indian climate. Since then I have continued to travel between architectural horizons well delineated in their splendid historical belonging and places much nearer, vaguely sinister, linked to the more transitory sphere of everyday life.

All ideas point to images, just as all images ultimately make us reflect, intuit something. Thus, now that the realm of photography is peopled by countless subjects with their respective stories, including various forms of reinterpretation, we can begin to examine the effect that photography produces in contact with contemporary architecture, as though this encounter generated a type of autonomous, original image. I look, find and trivially count, for example, the windows, the openings, the landscapes that I have shot over the years, first with a sort of unthinking fascination and then gradually collected with growing curiosity, as though these points, despite their irrelevance, in some way documented the intrinsic diversity of the subjects before me. The windows, which we can term intermediate spaces, like the landscapes, other illusory spaces created by a dilatated perception, now seem to me as compositions strictly linked to the sign that the architecture transmitted to me.

At times photography seems to circumvent the photographer, automatically aiming itself toward one of these points, recognizing in contemporary architecture this dual identity: of being unitary, compact and at the same time transparent, transfixed by the light; or affixed to the landscape, to the ground, and at the same time evidencing its physical detachment.

We frequently use the binding, restrictive expression "representation" of architecture. This formula probably came down to us from that distant period when Renaissance architecture was the subject of photography par excellence. We might now imagine we have entered a period when considering architecture in photographs corresponds to a perception that is no longer frontal but continuous, where the whole assumes a relationship to detail, as though this were the password to the general scene and vice versa. This characteristic relates particularly well with the prerogative of photography today, in its digital form, to propose to the photographer an inexhaustible capacity for transformation and representation, shifting each (nostalgic) reference to the inexorable authenticity of photographic experience.

Paolo Rosselli

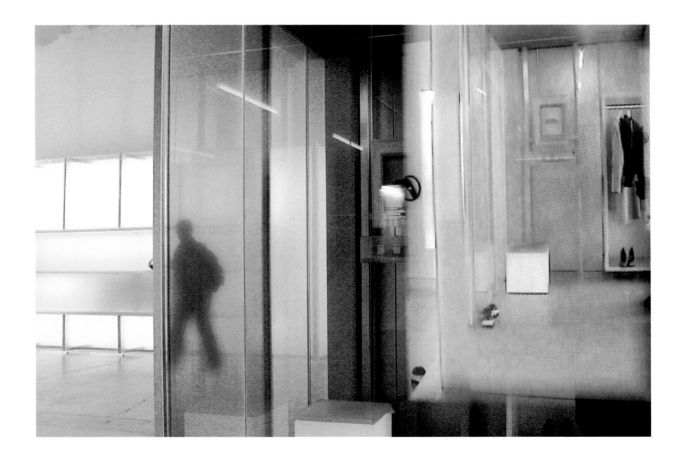

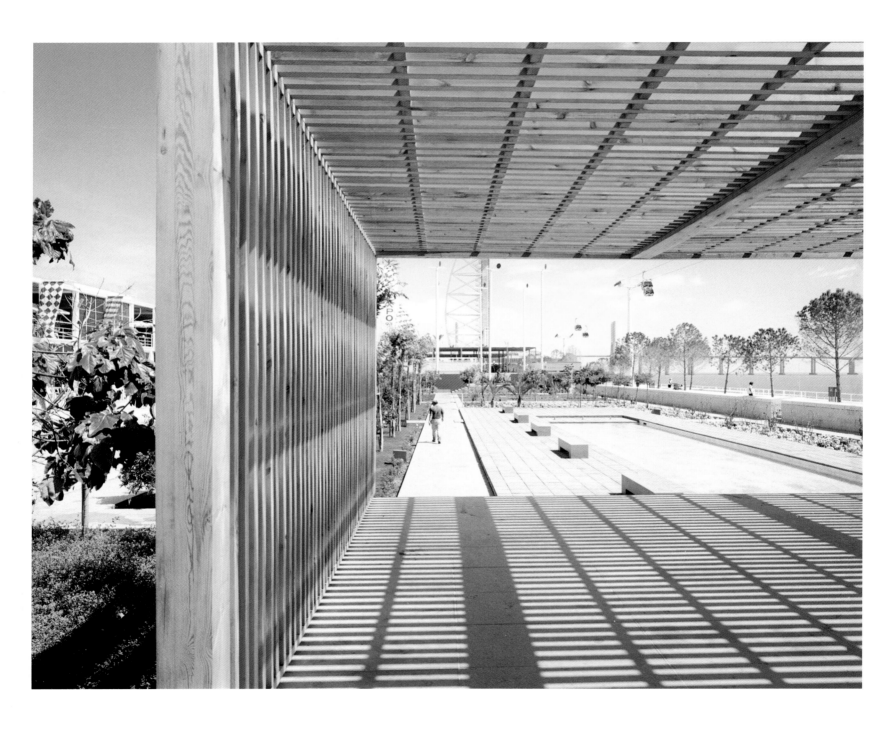

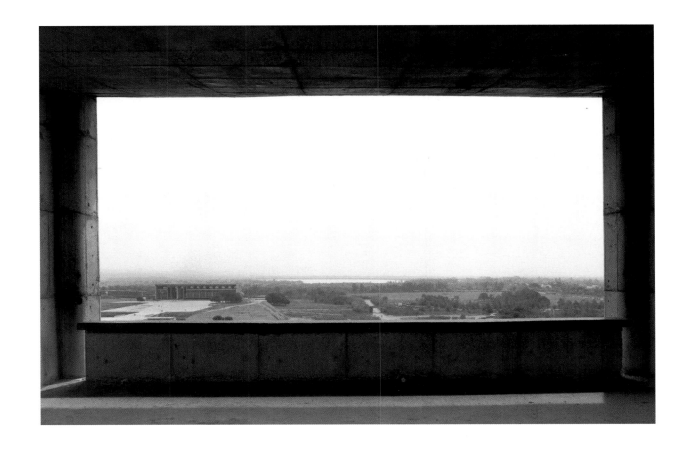

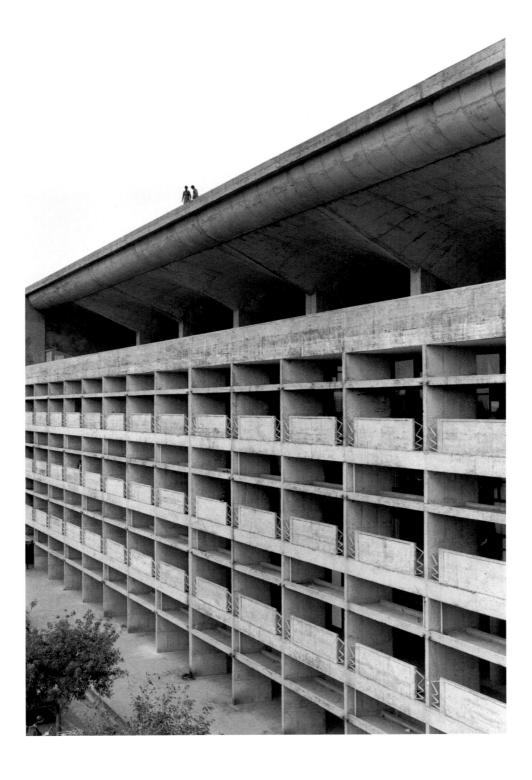

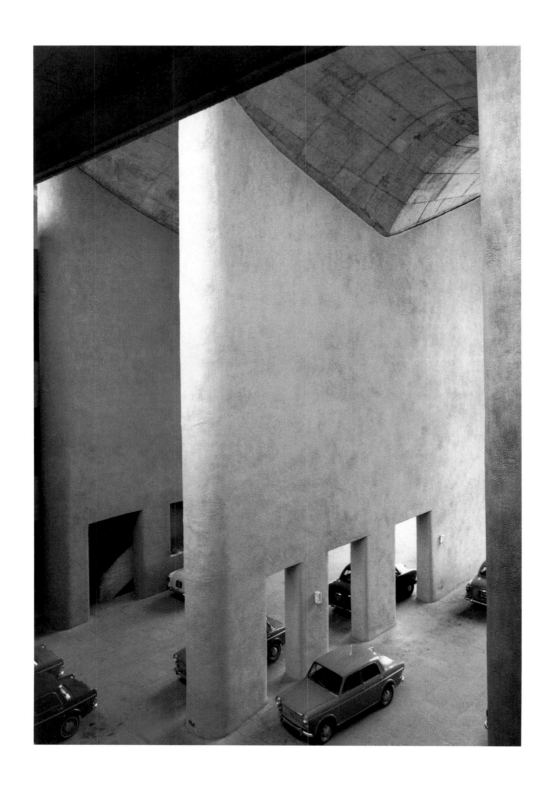

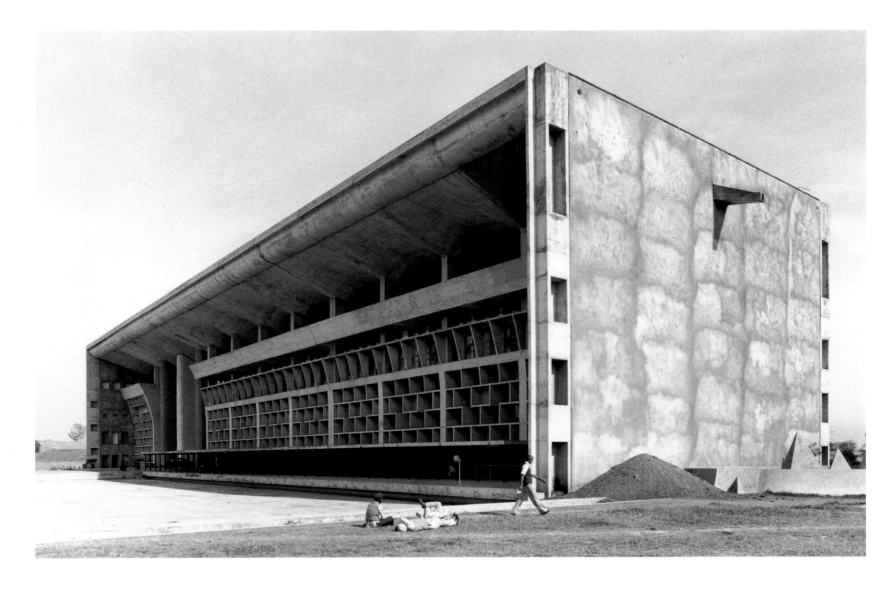

Chandigarh, The Parliament, 1981
Le Corbusier, 1951-65

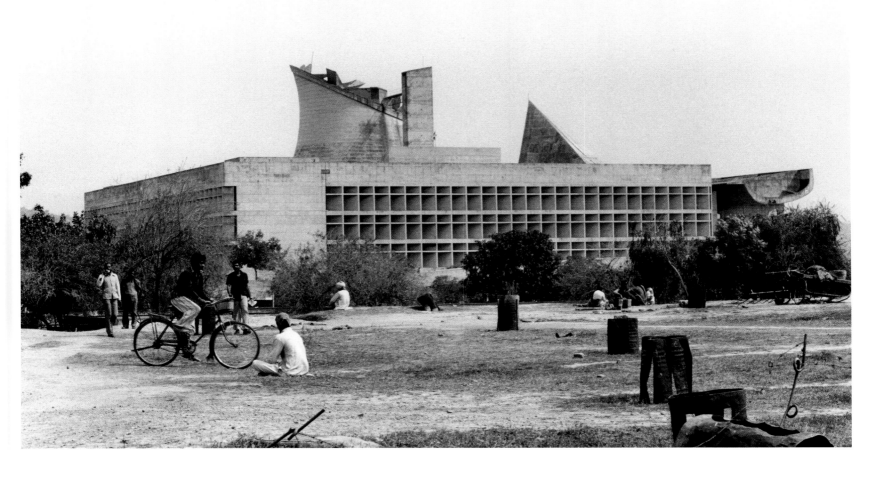

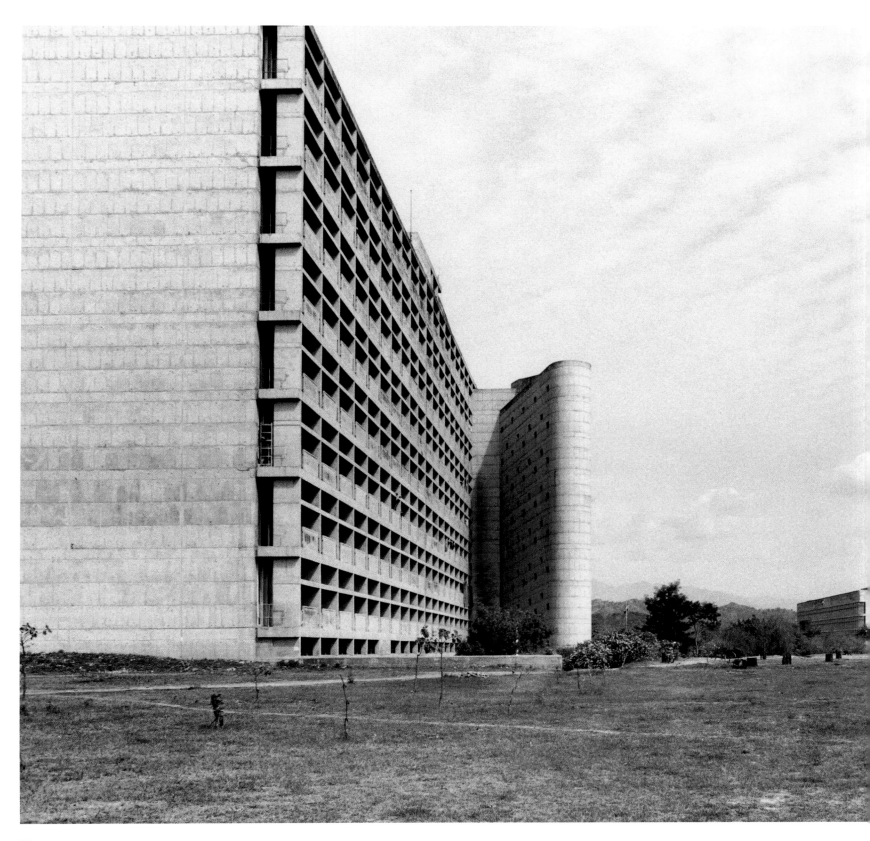

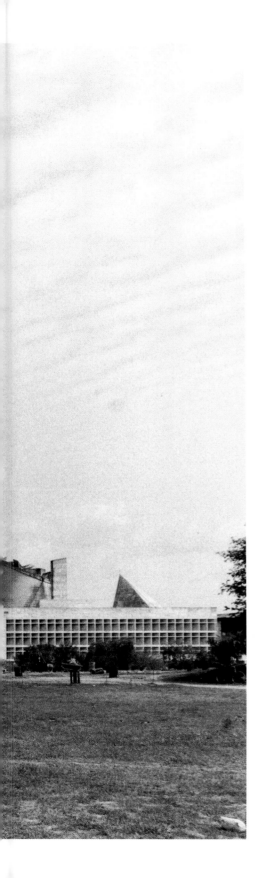

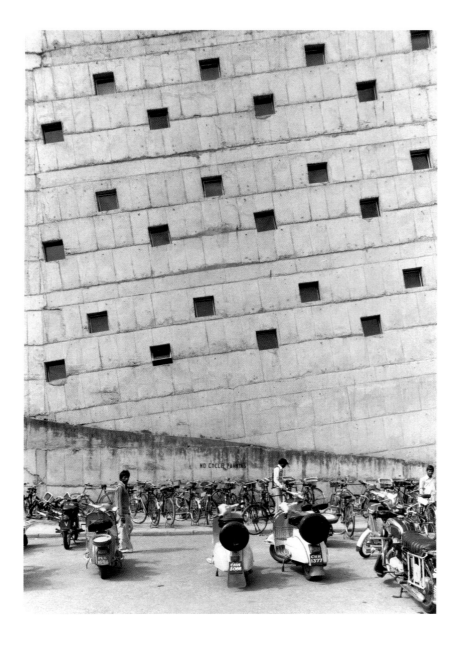

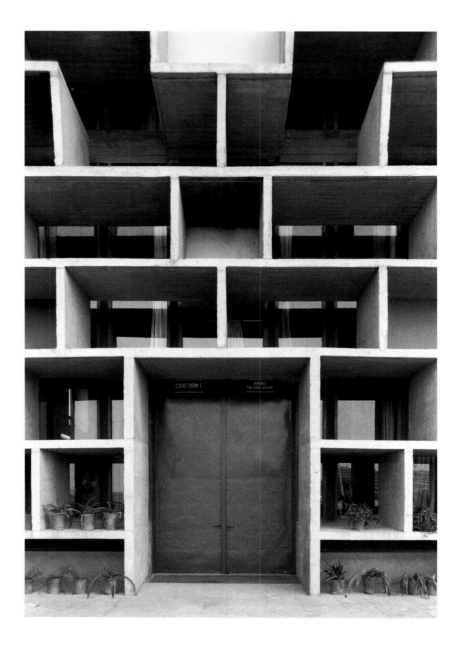

Appendix

Selected Exhibitions

Solo Exhibitions

1987
Basel, Architekturmuseum, "News from Engadin".

1992
Genoa, Museo S. Agostino, "Recent Architecture in Genoa".

1996
Parma, Nuova Galleria del Teatro, "Messaggi Personali".

1997
Basel, Architekturmuseum, "Das Italien Jacob Burckhardt".

1998
Innsbruck, Fotoforum-West, "On Words and Signs".
Rome, Swiss Institute, Villa Maraini, "Renaissance Architecture in Photography".

2000
London, Volume Gallery, "Recent European Architecture".

Collective Exhibitions

1987
Milan, XVI Triennale, "Le città immaginate".

1990
Reggio Emilia, "Architectural Photographs in Europe".

1992
Chur, Bundner Kunstmuseum, "Du grosses stilles leuchten".

1993
Venice, XVL Biennial, "Photography and Landscape after the Avant-garde".

1995
Milan, Triennale, "Il centro altrove" Suburban landscapes.

1996
Milan, Triennale, "Architecture of the Reconstruction, Milan 1950-1960"

1998
Milan, Fondazione Bruno Danese, "37 Photographers for 37 Frames".

2000
Portland OR (USA), "Architecture in Photography".

Selected Bibliography

1980
L'arte dell'amore in India e Nepal, text by Arturo Schwarz, Laterza, Rome-Bari.
1983
Il culto della donna nella tradizione indiana, text by Arturo Schwarz, Laterza, Bari.
1985
Engadin, Architektur und Umwelt, Desertina Verlag, Chur.
1989
Juan Navarro Baldeweg, Electa, Milan.
1992
Genoa 1992, the Painted City, Lotus Documents, Electa, Milan.
Du grosses stilles leuchten, Bündner Kunstmuseum, Offizin Verlag, Zürich.
Creatures from the Mind of Santiago Calatrava, Artemis Verlag, Zürich.
1996
Paolo Rosselli - Messaggi Personali, Archivi della fotografia, Csac-Skira, Parma-Milan.
Milano Moderna, text by Fulvio Irace, Motta Editore, Milan.

1997
Das Italien Jacob Burckhardt, Architekturmuseum Editions, Basel.
1998
Santiago Calatrava, Work in Progress, text by Luca Molinari, Skira, Milan.
1999
Antica città moderna: vedute contemporanee di Matera, text by Fulvio Irace, Edizioni Libria, Matera.
Santiago Calatrava, text by Alexander Tzonis, Rizzoli International Thames and Hudson, London.

Note

An important part of the photographs published
in this volume are the result of a project
initiated in the mid-80s for *Lotus International*,
a magazine with which I still collaborate.
The photographs of the Vitra Museum were
taken for the magazine *Ottagono*.
The images of the works of Santiago Calatrava,
on the other hand, were taken directly for
Studio Calatrava beginning during that same
period. The photographs of Mario Botta's
architecture were also taken on commission.
An exception to this rule was a series of works
realized for my own interest: this is the case
of Tate Modern, Stockwood Park, Chandigarh,
Sturges House in Los Angeles and Isozaki's
project for the Fashion Biennial in Florence.
The first photographs of Moretti's building also
belong to this group; a subsequent publication
mentioned separately concerned this
architect's work in Milan.

Studio Rosselli has the following e-mail address:
rosselli@iol.it